IMAGES
of Aviation

TORRANCE
AIRPORT

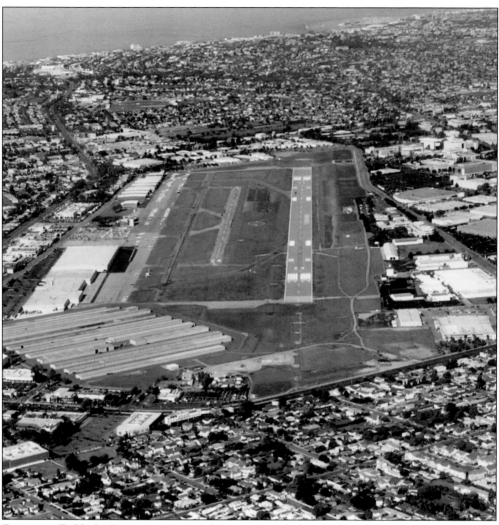

Zamperini Field, the Torrance Municipal Airport, nestled in the heart of Los Angeles County's South Bay area, grew from a few acres of lima beans and alfalfa to an airport with one of the most unique and fascinating histories in the nation.

ON THE COVER: First Lt. Richard G. Simpson of the 434th Fighter Squadron, 479th Fighter Group, was selected to represent the pilots of four P-38 squadrons that flew to war from the Lomita Flight Strip. His combat awards include the Air Medal with six Oak Leaf Clusters, the Distinguished Flying Cross, and the Purple Heart. (Courtesy Air Force Historical Research Agency.)

IMAGES
of Aviation

TORRANCE
AIRPORT

Charles Lobb

ARCADIA
PUBLISHING

Published by Arcadia Publishing
Charleston, South Carolina

Printed in the United States of America

Library of Congress Catalog Card Number: 2006924923

For all general information contact Arcadia Publishing at:
Telephone 843-853-2070
Fax 843-853-0044
E-mail sales@arcadiapublishing.com
For customer service and orders:
Toll-Free 1-888-313-2665

Visit us on the Internet at www.arcadiapublishing.com

Dedicated to Nancy Clinton, the First Lady of the Airport.
Thank you, Nancy, for your friendship and unflagging support.

CONTENTS

Acknowledgments 6

Foreword 7

Introduction 8

1. The Prewar Years 9

2. World War II 23

3. The Postwar Years 63

4. Aviation Businesses 81

5. Robinson Helicopters 103

6. Louis S. Zamperini 115

Bibliography 127

ACKNOWLEDGMENTS

Ten years of research and hundreds of contributions are almost impossible to acknowledge properly. So many friends unhesitatingly contributed their time, scrapbooks, photographs, clippings, and recollections. Fighter pilots generously granted interviews and extended invitations to their squadron reunions. Albert Scott of the East Essex Aviation Society provided guide services at Wattisham Airfield in England. Forty slide presentations throughout the Los Angeles area frequently inspired spontaneous ideas from the audience.

My sincerest thanks to each and every one of the major contributors listed below for their time, photographs, and memories, which frequently led to rare and intriguing material.

Nancy Clinton, whose annual air fairs at the Torrance Airport and friendship for many years, inspired this book. Dick Gama and Archie DiFante of the Air Force Historical Research Agency (AFHRA), Maxwell Air Force Base, Alabama, furnished five rolls of 16-mm microfilmed records and photographs. Dan Corrigan of Continental Graphics brought these microfilmed images to life. Photographer Paul Pohl of Montgomery, Alabama, pulled dozens of archived AFHRA photographs and re-photographed them perfectly. The National Archives at Laguna Niguel, California, allowed me to sift through two cardboard boxes filled with Lomita Flight Strip history. Roger Keeney and Iris Critchell both allowed me to pick their brains, file cabinets, and scrapbooks. And finally the *Lightning Strikes* newsletter of the National P-38 Association posted my request for information that brought a flood of responses from Lomita Flight Strip veterans.

I also acknowledge my deep indebtedness to all my friends on this project:

Bob Avakian, Nike missiles
Mike Blyleven, City Archives
Gil Ceferatt, P-38 Association
Virginia Doak, Doak Aircraft
Walter Drake, 434th pilot
Maria Gavin, television producer
Burl and Juanita Glass, 429th commander
David Harmon, photograph editing
Flamm "Dee" Harper, 434th pilot
Fred Hayner, 434th nose artist
Jack Ilfrey, 20thFG/55th Pursuit Squadron
Barbara London, WASP squadron commander
Ted Misenheimer, TOA photographs

Gus Morfis, Lomita research
Paul Nowatka, World War II history
Earl Ody, P-38 pilot
George Patik, 429th engineering
Bernard McNulty, 429th technician
"Vinny" Revis, Robinson Helicopters
Kurt Robinson, Robinson Helicopters
Karl Swindt, 20thFG/55th Pursuit Squadron
Bill Switzer, Bay Cities Airport
Anthony Turhollow, Army Engineers
Harry Waldron, LAAFB historian
"Hub" Zemke, 479th FG commander
Louis Zamperini, World War II survivor

FOREWORD

The story of the Torrance Airport is in many respects a story based on the spirit of unity that blossomed from World War II. It was a different time, a unique time, a time of unprecedented inspiration and resolve. We were struggling to emerge from a terrible economic depression when war was thrust upon us by foreign powers on opposite sides of the globe. The comfort of isolation between two large oceans had vanished; we had been attacked, and we were at war!

The future was uncertain but the country united. Industries of every kind swung into around-the-clock production. Young men clamored to join the military, the more impatient ones running off to Canada to join the Royal Canadian Air Force. I, too, felt the urgency and enlisted in the Army Air Corps three months before Pearl Harbor.

That enlistment proved to be a turning point few lives have experienced. My athletic achievements paled in comparison to the life-altering impact of drifting in the ocean for months on a tiny rubber raft, of narrowly escaping a beheading, then two and a half years of being at the mercy of a sadistic guard who knew no mercy. Yet through it all, my solid middle-class values formed from my solid middle-class upbringing in a solid middle-class community served me well. It formed a base all too often missing from many contemporary young lives.

This story of the Lomita Flight Strip, of Zamperini Field, of the Torrance Municipal Airport, is the first to be compiled and published. I am not sure I am deserving of the many honors bestowed on me, but I am very proud to be a small part of this seminal publication. It is hoped my life will provide inspiration to young people everywhere, that running the good race is what life is all about. It is what we are on this earth to do.

My thanks to Chuck Lobb for assembling this history of Zamperini Field in a way that allows each of us to appreciate the individuals who are so much a part of the Torrance community, its past as well as its present.

—Louis Zamperini
May 2006

INTRODUCTION

The attack on Pearl Harbor on December 7, 1941, sent panic up and down the almost defenseless West Coast. All flying within 200 miles of the coast was immediately halted, every airfield seized, and additional roads scraped out to potential invasion points. In February 1942, a Japanese submarine lobbed a few shells harmlessly into a Santa Barbara oil-tank farm. Two days later, Los Angeles sirens sounded and searchlights stabbed the night sky as antiaircraft guns rattled at a UFO, or maybe a weather balloon, an off-course B-25, or perhaps an actual Japanese aircraft was shot down, quickly scraped up, and hauled off by the army in deeply cloaked secrecy. The country was at war!

Among 40 airfields built by the Bureau of Public Roads was the Lomita Flight Strip, a nondescript piece of sheltered farmland in the southern Los Angeles area. Four squadrons of P-38 fighter pilots trained here. It produced six generals, two Air Force Academy commandants of cadets, the judge of the Charles Manson trial, and the first runway takeoff of a ducted-fan vertical takeoff and landing (VTOL) aircraft. It housed Japanese Americans returning from internment camps and a cold war-era Nike missile battery. Today the same land is home to the world's largest manufacturer of civilian helicopters.

This book is the first attempt to publish the story of Zamperini Field. Over 400 photographs, maps, letters, squadron yearbooks, 8,000 frames of microfilmed squadron diaries, plus dozens of personal interviews were distilled into the essential information on the field. Apologetically a few stories will have to wait for future publication, such as the history of the Civil Air Patrol, the P-40 restoration Project Tomahawk, many pilot war stories, and the story of dozens of on-field businesses.

Throughout the historical research, accuracy has been stressed. Dusty scrapbooks and fading memories had to be corroborated, squadron reports and archived correspondence verified, yet inevitably a few inaccuracies may have crept in. The deepest apologies go out for these, the inevitable consequence of any lengthy historical search. The Bay Cities Airport in northern Torrance, for example, was colloquially known as the Torrance Airport or the Torrance Community Airport. Until Bay Cities disappeared under the housing developers' bulldozers, these names were frequently commingled.

Whether flipping through the photographs or seriously studying the text, the story is a fascinating one. It was lots of fun pulling it together. Hopefully people will enjoy reading it.

One

THE PREWAR YEARS

The history of the Torrance Airport was stimulated by the birth of aviation in California, beginning with the Dominguez Air Races of 1910 on land that is now part of the city of Carson. The first such event in the nation, the air races prompted half the population of Los Angeles to ride the Pacific Electric Red Car railway south to Dominguez Hills to watch the flying machines of Glenn Curtiss, Lincoln Beachey, and Charles Hamilton. Twelve-year-old Edmond Doak was inspired enough to launch what would later become a distinguished engineering career in aviation (see Chapter 4). Van Griffith built the Griffith Park Airport in 1911. Movie producer Cecil B. DeMille built Mercury Field in 1918 near Wilshire and Fairfax. Flying weather was good, surplus World War I aircraft were abundant, and aviation thus came of age in the 1920s. Clover Field at Santa Monica was dedicated in 1923, and the Blair Flight School in Culver City taught flying to Clark Gable, Jimmy Stewart, Ruth Chatterton, and Henry Fonda.

By 1927, 52 airports had sprung up in Los Angeles, 37 of these privately owned. Mines Field (now Los Angeles International Airport or LAX) hosted the National Air Races in 1928, 1933, and 1936. Aviation boomed in this barnstorming era, with no fixed base or governmental regulations. However while barnstormers thrived with plenty of ability and ambition, the general public saw these aircraft only as thrill rides. Speed, comfort, and safety were unknown until the Grand Central Airport in Glendale was dedicated in 1929, ushering in commercial airline service with Maddux Airlines and Transcontinental Air Transport.

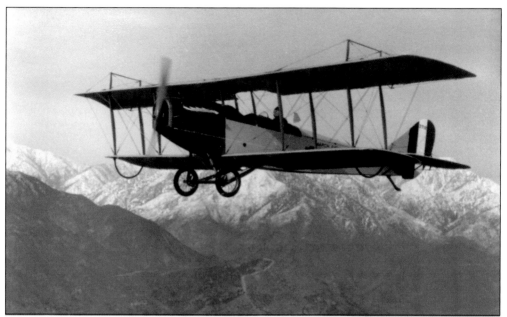

As World War I ended, pilots returning from the war eagerly sought surplus Army Air Corps aircraft. The popular Curtiss JN-4D "Jenny," with a 90-horsepower OX-5 engine, could be purchased for as little as $300. Pilots and would-be pilots bought them up and barnstormed across the southland. (Courtesy Roger Keeney.)

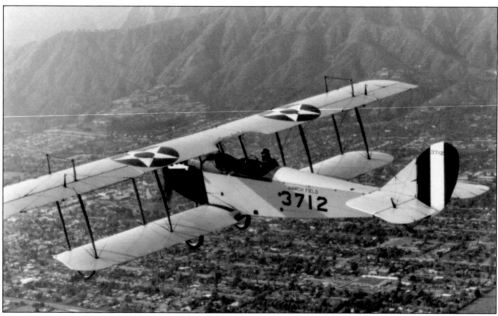

Unimproved airports rarely bothered anyone except a few farmers. Pilots simply landed on open farmland or wherever sufficient space was available and occasionally took off immediately if the farmer came running to collect a landing fee. Barnstorming became popular as the novelty and thrill of flying gained momentum. (Courtesy Roger Keeney.)

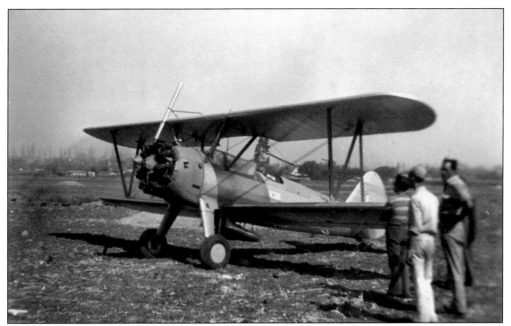

Small airports continued to grow at a steady pace in the 1920s, each one little more than a strip of grass with one or two buildings. By 1927, 52 of these strips dotted Los Angeles County, and the total eventually reached 66. Aviation received another boost when Mines Field (now LAX) was visited by the Graf Zeppelin on August 26, 1929, during its 20,000-mile, west-to-east voyage around the world. (Courtesy Roger Keeney.)

Designed in 1926 by Lloyd Stearman in Venice, California, the Stearman PT-13 "Kaydet" open cockpit biplane was fitted with a Lycoming 220-horsepower engine and manufactured by Boeing for army and navy primary pilot training. By 1941, pilot training reached 30,000 individuals per year, 100 times the 1939 level. Twenty new Army Air Corps training bases were completed or under construction by December 1941. (Courtesy Roger Keeney.)

11

This Travelair 2000, with an OX-6 engine, was built with horn-balanced control surfaces copied from the famous Fokker D-VII from World War I. It was a popular aircraft in the late 1930s, and it frequently appeared in movies as the Fokker. (Courtesy Roger Keeney.)

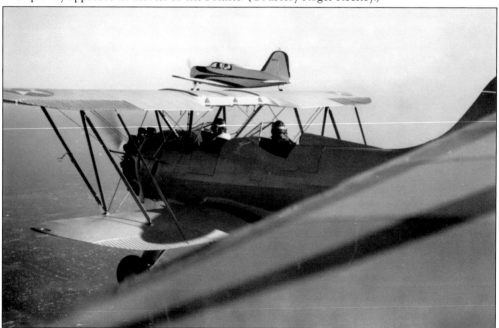

This open cockpit Stearman PT-13 (foreground) is in formation with an unusual Harlow PJC-2 (background), one of only 11 built to the designs of students at Pasadena Junior College (PJC). Very advanced for the late 1930s, the Harlow featured stressed aluminum skin and electrically retractable landing gear. (Courtesy Roger Keeney.)

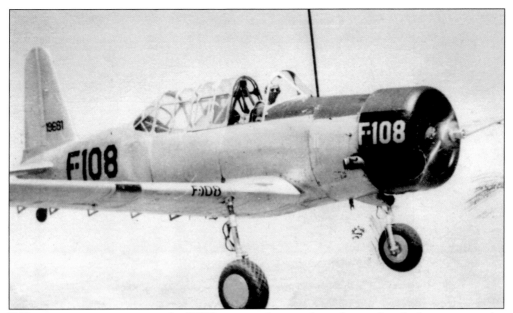

Following primary training in the PT-13, army and navy pilots advanced to the basic trainer, the BT-13 (basic trainer) Vultee "Valiant" (navy designator SNV 2) built by Vultee Aircraft in Downey, California. Promptly renamed the "Vibrator" by student pilots, it featured a 450-horsepower Pratt and Whitney engine, a two-position propeller, and a two-way radio that required more attention in flight from the pilot. (Courtesy Earl Ody.)

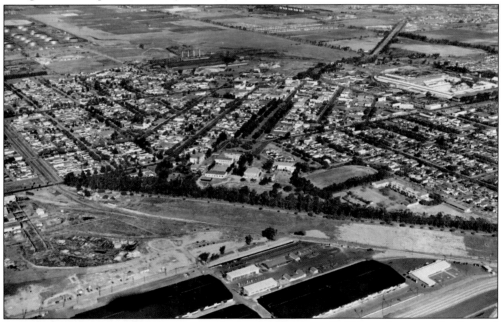

By World War II, the city of Torrance, California, had grown to 10,000 residents, mostly clustered around the central business district. Torrance High School is in the center at the end of tree-lined El Prado Avenue. The four smokestacks (upper left) belong to the Columbia Steel Mill and the white buildings (upper right) are the Union Tool Company, manufacturers of oil-drilling equipment. (Courtesy Torrance Chamber of Commerce.)

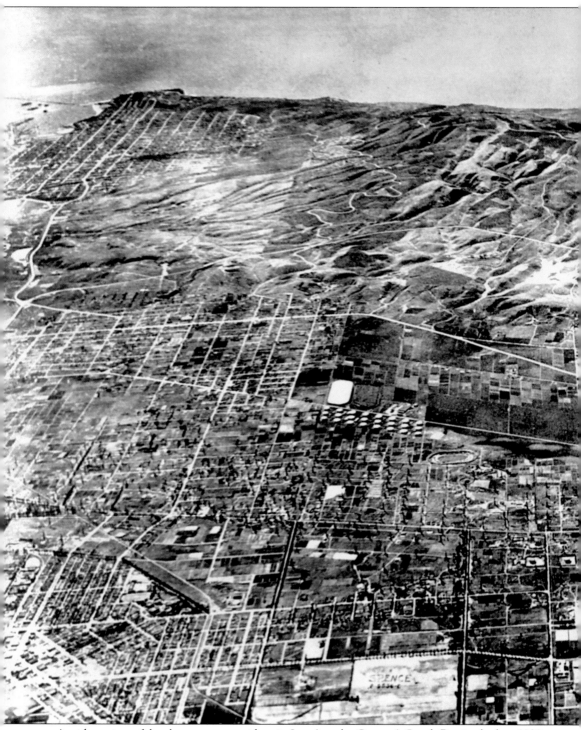

A wide variety of development was evident in Los Angeles County's South Bay in the late 1930s, from San Pedro (upper left corner) to Redondo Beach (right coastline) to downtown Torrance (lower left corner). The dark area (center) at the base of Palos Verdes featured small agricultural

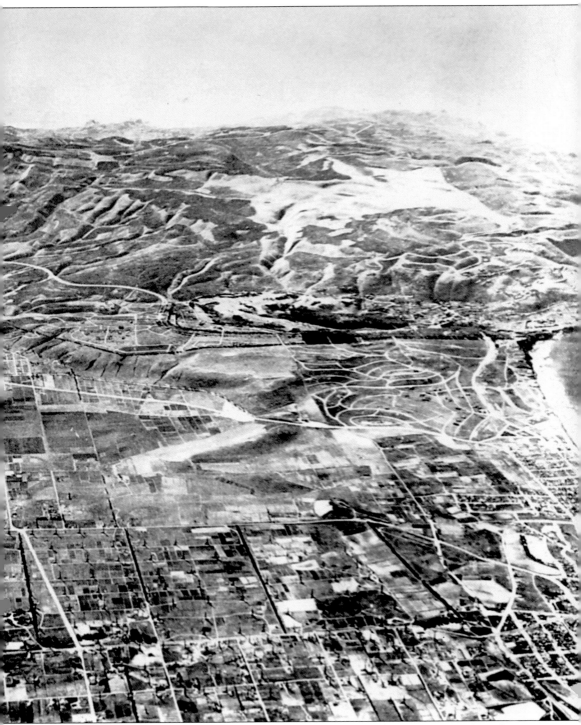

plots kept moist by two seasonal streams. Oil wells dotted the landscape while Roosevelt Highway (now Pacific Coast Highway) and Hawthorne, Lomita, and Sepulveda Boulevards are all clearly visible. (Courtesy Bill Switzer collection.)

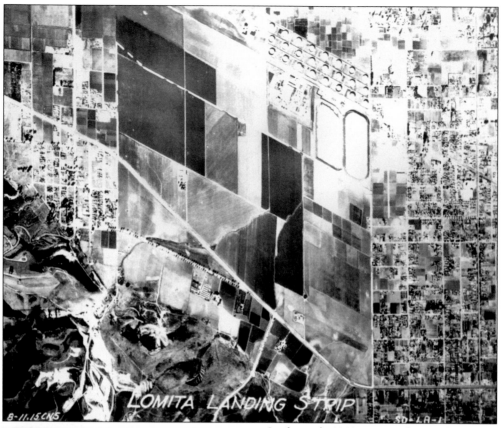

In the early 1940s, tenant farmers J. R. Veitch of Long Beach and A. P. Wright of Los Angeles leased acreage from the Weston Investment Company for lima bean and alfalfa agriculture. Seven farmhouses, a greenhouse, and 13 general farm buildings were constructed. Irrigation water was pumped from several water tanks filled by three wells of 500 and 550 feet to augment two seasonal runoff streams. (Courtesy National Archives-Pacific Southwest Region, Laguna Niguel, California.)

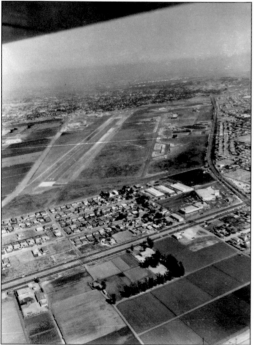

The Bureau of Public Roads Project FS-5, funded by the Defense Highway Act of 1941, purchased 480 acres from Ben Weston for $380,000 and began around-the-clock construction of the flight strip. The first task was to bring the sunken farmland up by four to five feet by quarrying truckloads of soil from the Palos Verdes hillside. A 5,000- by 150-foot runway with aprons was completed, probably by late 1942. (Courtesy City of Torrance.)

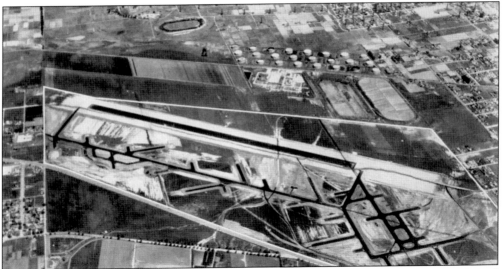

The U.S. Army Corps of Engineers then took over completion of the taxiways, hardstands, and 39 buildings to house squadrons of P-38 fighters for final training prior to overseas deployment. Oil wells, Lomita Boulevard, and an oil-tank farm are clearly visible at the top, as well as Pacific Coast Highway and the tree-lined Newton Street at the bottom. (Courtesy National Archives-Pacific Southwest Region, Laguna Niguel, California.)

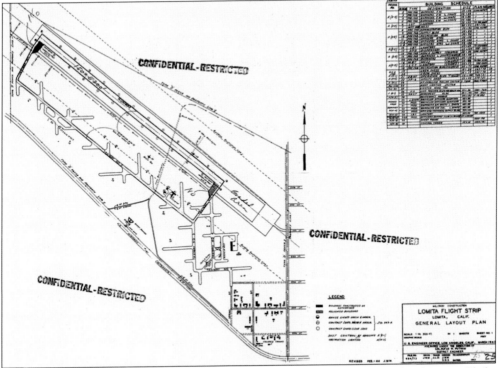

By March 1943, this U.S. Army Corps of Engineers general layout of the completed Lomita Flight Strip listed separate barracks, mess halls, a lavatory, and recreation buildings for African American soldiers. A single 34-foot by 192-foot, open-sided maintenance hangar and a skeet range were provided along with a control tower atop a small shed at midfield. (Courtesy Army Corps of Engineers.)

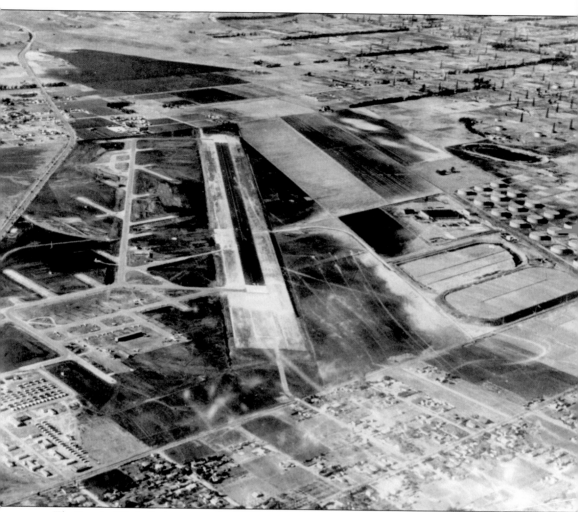

The Lomita Flight Strip was completed on March 31, 1943, and ready for occupancy. Note seasonal Walteria Lake (dark area, top), Pacific Coast Highway (left), and oil wells and oil tanks (upper right). The tanks are still a major landmark today. Crenshaw Boulevard stopped at Sepulveda Boulevard. After the war, the barracks and administration buildings (lower left) would be razed for the Rolling Hills Shopping Center. (Courtesy Torrance Chamber of Commerce.)

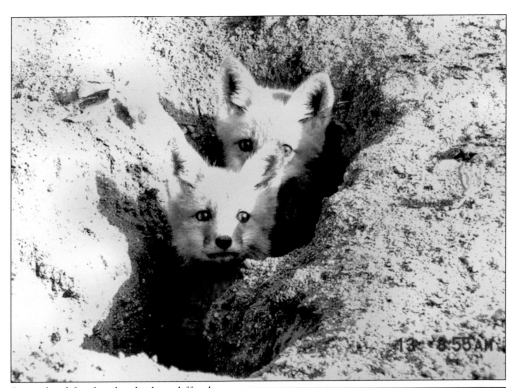

Several red fox families had no difficulty finding homes and food in the spacious adjoining fields. Cottontails and jack rabbits provided abundant dining for the foxes, as well as targets for pilots with shotguns. The pilots were developing keen eyes for pursuing fast-moving targets. (Courtesy Nancy Clinton.)

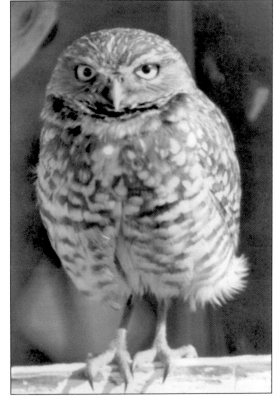

Burrowing owls also found plenty of homesites in the open fields. An abundance of field mice, voles, and rabbits kept their offspring healthy and well nourished. (Courtesy Roger Keeney.)

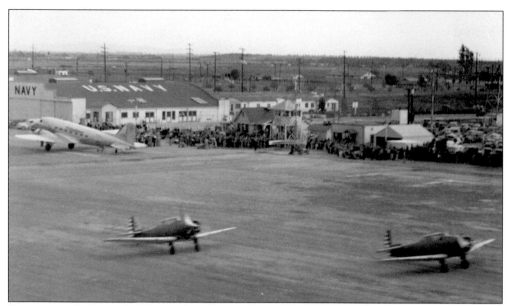

Base support functions for Lomita Flight Strip were placed under the purview of the long-established Long Beach Army Air Field. Built in the 1920s as the area's first municipal airport, it was named for pioneer aviator Earl S. Daugherty, who was also its first airport manager. During World War II, the field initially housed naval aviation units and then the 6th Ferrying Group of the Army Air Corps when the navy moved to Los Alamitos. (Courtesy The Historical Society of Long Beach.)

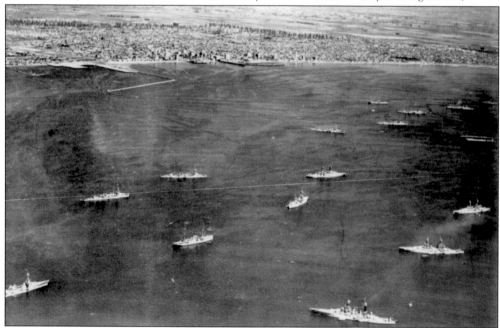

As war clouds gathered, the ports of Los Angeles and Long Beach began to fill with warships. In the late 1930s, some of the Pacific fleet was moored offshore. Ships with two smokestacks are battleships, and those with four stacks are cruisers. Most were destroyed at Pearl Harbor on December 7, 1941. The aircraft carrier USS *Langley* (far right) was sunk by Japanese aircraft between Java and Australia on February 27, 1942. (Courtesy The Historical Society of Long Beach.)

Introduced in 1938, the most sophisticated training aircraft in World War II was the North American AT-6 (navy SNJ) "Texan," used for advanced training, tactics, and ground support. Fitted with a single .30-caliber machine gun and a Pratt and Whitney 600-horsepower radial engine, it was known as "a pilot's aircraft." More than 17,000 were produced, and it was known as the most advanced two-seat training aircraft. (One seat was for the instructor.) (Courtesy Juanita Glass.)

For pilots anticipating multiengine assignments, such as those on bombers, transports, or the twin-engined P-38, the Curtiss AT-9 "Fledgling" was a trainer designed to bridge the gap between single and multiengine combat aircraft. Fitted with two Lycoming 295-horsepower radial engines, the Fledgling was not easy to fly and was a good training craft for pilots who would eventually fly the Martin B-26 or the Lockheed P-38. Pilots practiced safety and engine-out procedures in flight and during takeoffs and landings.

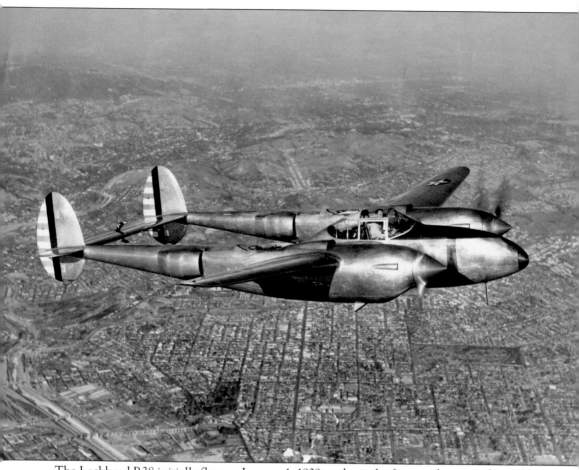

The Lockheed P-38 initially flew on January 1, 1939, and was the first combat aircraft capable of 400 miles per hour in level flight and a 40,000-foot service ceiling. The prototype YP-38 pictured here, one of 13 ordered by the Army Air Corps, has famed Lockheed test pilot Milo Burcham at the controls. Production P-38F, G, and a few J models were flown by the squadrons based at the Lomita Flight Strip. (Courtesy City of Torrance.)

Two

WORLD WAR II

Upon completion of construction of the Lomita Flight Strip on March 31, 1943, the Army Corps of Engineers transferred it to the Fourth Air Force, IV Fighter Command, Los Angeles Fighter Wing for use as a complete tactical air unit. Fighter groups and squadrons were being formed at the Grand Central Air Terminal in Glendale, California, by combining experienced P-38 pilots from squadrons such as the 332nd Fighter Squadron at Santa Ana Army Air Base with newly trained pilots from Williams Army Air Field in Arizona. The units assigned to the Lomita Flight Strip were the 55th Pursuit Squadron in June 1943 (for two weeks of completion training after general training at March Army Air Field in Riverside County), the 373rd Fighter Squadron from July to October 1943, the 429th Fighter Squadron in January 1944, and the 434th Fighter Squadron from February to April 1944.

In addition, the headquarters of the 479th Fighter Group was colocated there with the 434th Fighter Squadron. The 373rd was a Replacement Training Unit (RTU), training replacement pilots for individual assignments to other combat units. All other squadrons were Operational Training Units (OTU), remaining intact as tactical combat units. All OTUs were deployed to the European theatre of operations (ETO). In August 1944, the Fourth Air Force turned the field over to the 6th Ferrying Group, Air Transport Command, at Long Beach for use by the 556th Army Air Force Base Unit. The 556th managed the field until the war ended and the field closed in September 1945. Thereafter the commander of the 6th Ferrying Group granted permission to the Third Region Civil Air Patrol to continue to remain active. The CAP had been using the field since December 28, 1944.

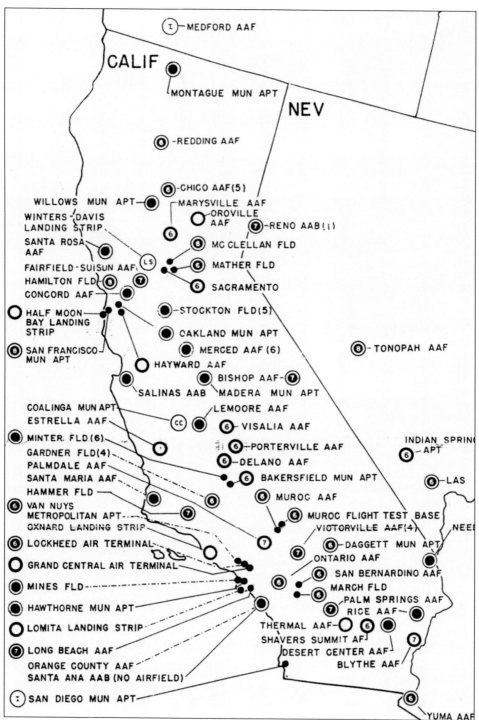

The Lomita Flight Strip was one of over 100 military airfields in the seven Western states, including 60 in California. Fighter-squadron training was largely coordinated from the Grand Central Air Terminal in Glendale, California, the largest civilian airport in the west prior to the war. (Courtesy Paul Nowatka.)

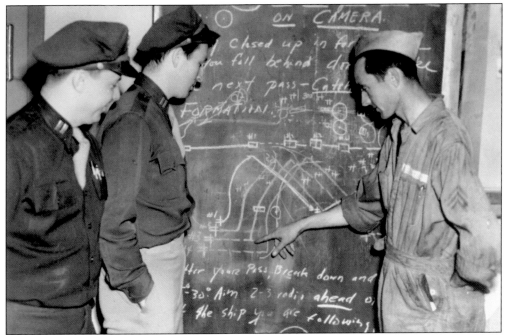

Simulated combat was the primary flying training mission. Missions were scheduled in formation flying, cross-country navigation, radio techniques, gunnery with cloth targets towed behind a B-26, strafing rafts coordinated with the navy and often targeted at rocks off Santa Catalina Island, desert flying, and simulated aerial combat, or "dogfighting." (Courtesy Air Force Historical Research Agency.)

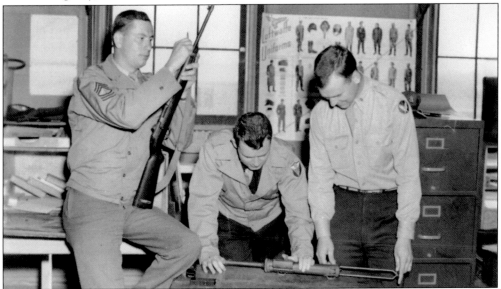

In this photograph, preparation is underway for a class in the .30-caliber M30 carbine and the .45-caliber automatic "Grease Gun" by Master Sergeant Wilcox (left), Chief Warrant Officer Clark (center), and Lieutenant McClain. Note the poster describing Luftwaffe uniforms and the interior of this typical hastily constructed wooden building. (Courtesy Air Force Historical Research Agency.)

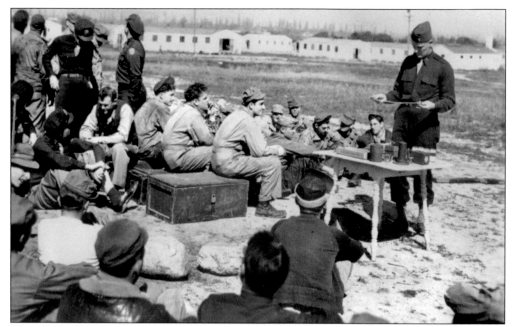

This class in decontamination procedures does not seem to be holding the attention of two pilots (standing left). Note the barracks in the background that housed and fed up to 280 enlisted men. Most pilots found the barracks too Spartan and used their housing allowances to live off base in private homes, apartments, and hotels. (Courtesy Air Force Historical Research Agency.)

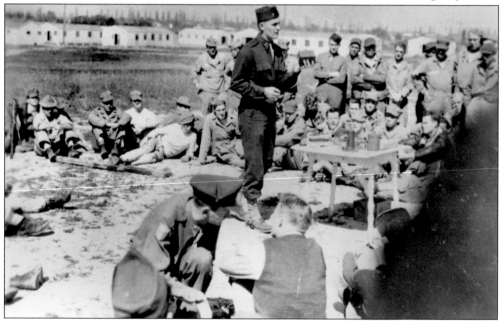

Ground instruction included small arms qualification, aircraft identification, decontamination procedures, and physical training. After the war, from December 1945 to April 1946, the barracks housed Japanese American families returning from internment camps. Eventually all LFS buildings were razed to make room for Crenshaw Boulevard and the Rolling Hills Shopping Center. (Courtesy Air Force Historical Research Agency.)

Captain McElhinney spikes a hard one during physical-education practice. Softball and basketball teams were also organized and played in local leagues and against squadrons based at Palmdale and Oxnard. Note the wooden building, scrub vegetation, and distant Torrance oil wells. (Courtesy Air Force Historical Research Agency.)

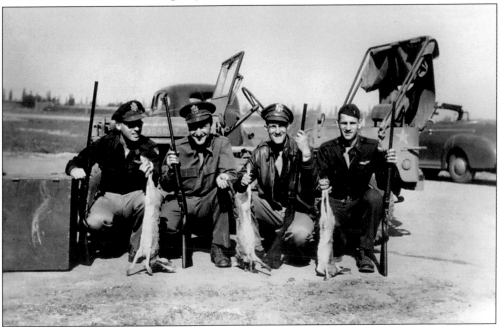

It wasn't all nose to the grindstone. Four pilots appear to have had some success locally, evidenced by the three jackrabbits bagged on the field. Pictured here, from left to right, are Lts. B. E. Hollister, Ted Anastos, James Wallace, and Bill Hehn. Lieutenant Anastos was the squadron armorer who provided the shotguns. (Courtesy Air Force Historical Research Agency.)

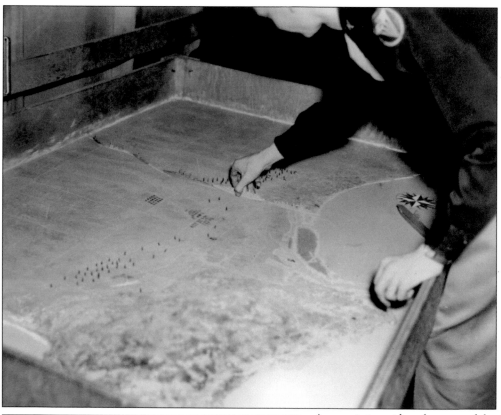

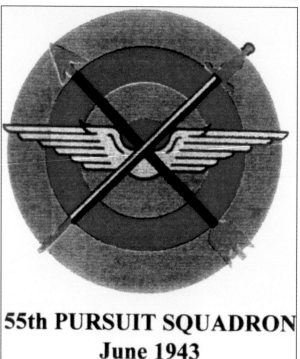

55th PURSUIT SQUADRON
June 1943

As a training aid, a plaster model of the Palos Verdes Peninsula was constructed as it would appear from a P-38 at about 18,000 feet. Note the detailed oil derricks and storage tanks and the careful placement of a convoy of warships heading up the Los Angeles River. (Courtesy Air Force Historical Research Agency.)

In June 1943, 25 P-38s, 40 pilots, and 200 enlisted men of the 55th Pursuit Squadron, based at March Army Air Field in Riverside, deployed to the Lomita Flight Strip for 14 days. The purpose was to complete 10 hours of P-38 familiarization, gunnery work, and general workup prior to overseas deployment. Note that the designation "Fighter," rather than "Pursuit," had not yet been introduced. (Courtesy Ken Ashbaugh, 20th Fighter Group.)

The commanding officer of the 55th was Capt. David R. McGovern of Providence, Rhode Island. Assigned to the 20th Fighter Group on December 17, 1942, he assumed command of the 55th Pursuit Squadron on January 12, 1943, after completing a tour of duty in the Pacific theatre. (Courtesy Karl Swindt.)

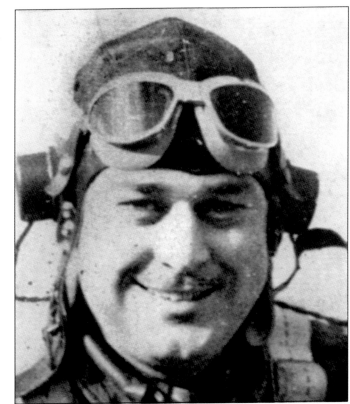

The squadron's P-38s were equipped with four .50-caliber machine guns and one 20-mm cannon in the nose pod in front of the cockpit. Pilots commented on being the first units assigned to the Lomita Flight Strip; the concrete runways and taxiways were fresh, white, unstained, and unmarked. (Courtesy Ken Ashbaugh, 20th Fighter Group.)

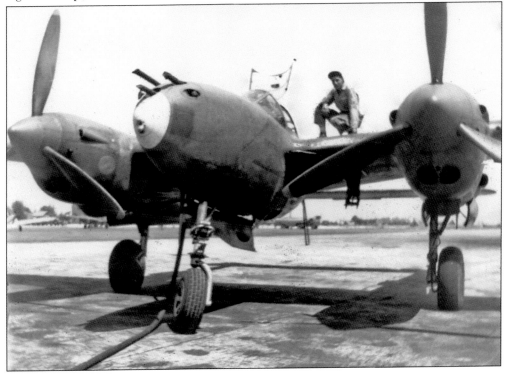

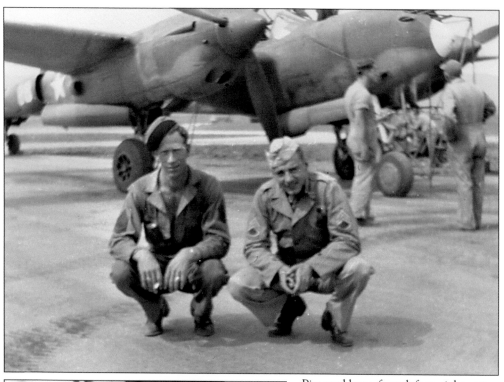

Pictured here, from left to right, are T.Sgt. Clarence Wiklund and S.Sgt Shirley Reisig as they take a break on the Lomita flight line. (Courtesy Ken Ashbaugh, 20th Fighter Group.)

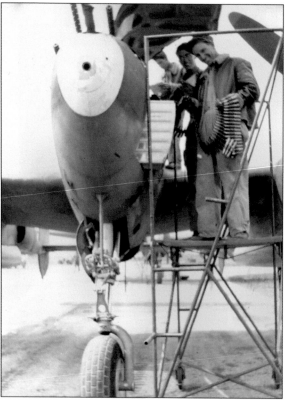

Armorer Pfc. Carl Barlow services a P-38 gun pod with .50-caliber ammunition. Note the maintenance platform required to reach the gun compartment of this large fighter. (Courtesy Ken Ashbaugh, 20th Fighter Group.)

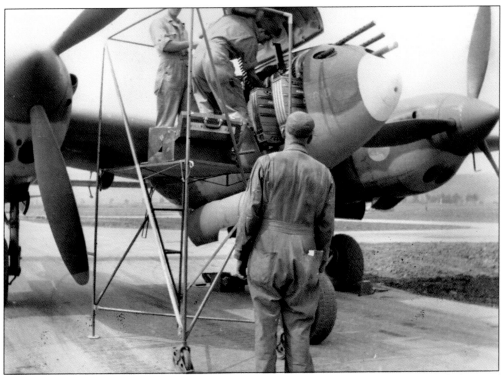

Access to the nose pod was also available from the right side. Pilot training included plenty of live firings, usually against floating ocean targets, sleeves, or banners towed behind a B-26. Fifty-caliber ammunition was tipped with colored paint to identify the pilots who had successfully struck the towed banner. (Courtesy Ken Ashbaugh, 20th Fighter Group.)

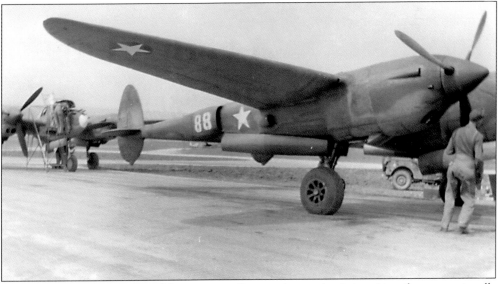

Summer weather in 1943 allowed for maximum flying and ground training. Aircraft were continually aloft, keeping ground crews busy refueling and restocking aircraft between flights. By the end of June, the 55th Fighter Squadron returned to March Field, and in August, the entire 20th Fighter Group boarded the *Queen Mary* for Europe. (Courtesy Karl Swindt.)

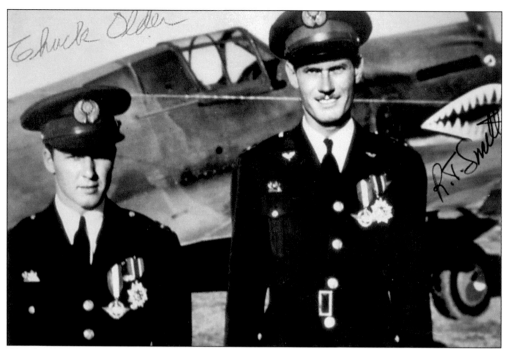

Charles Older, left, and Robert T. Smith were both aces with the Flying Tigers. When the Tigers disbanded in July 1942, Older accepted a commission in the Army Air Corps and was given command of the 373rd Fighter Squadron. The 373rd was assigned to the Lomita Flight Strip from July to October 1943 for training a steady stream of replacement pilots who were mostly sent to Europe with a few to the Pacific. (Courtesy Kent Lentz.)

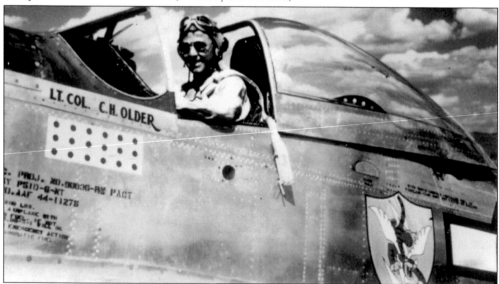

Maj. Charles Older's combat experience proved invaluable in training new pilots fresh from Williams Field in Arizona. In late 1943, as the need for replacement pilots subsided, Older returned to China where he flew P-51s, amassing a total of 18 aerial victories. After the war, he entered the legal profession, became a judge in Los Angeles Superior Court, and presided over the Tate/La Bianca murder trial of Charles Manson and his cult followers. (Courtesy Charles Older.)

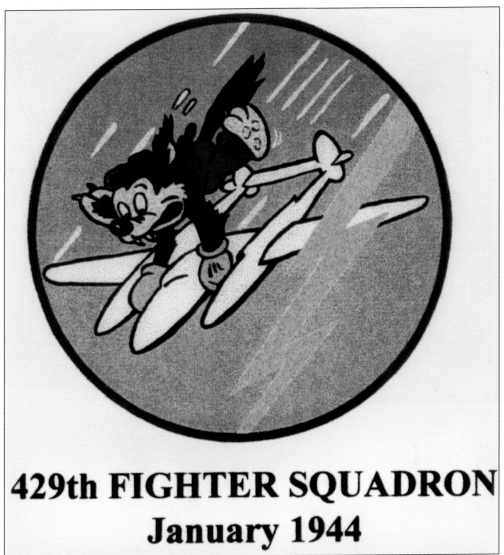

429th FIGHTER SQUADRON
January 1944

Many pilots of the 429th Fighter Squadron were dismayed with this insignia designed by Walt Disney, since other units had more snarling, aggressive creatures. Nonetheless it was gratefully accepted as the 429th relocated to the Lomita Flight Strip on January 4, 1944. Forty-one officers and 248 enlisted men took up residence as the first Operational Training Unit (OTU) at Lomita, an intact squadron that remained together as a unit. (Courtesy George Patik.)

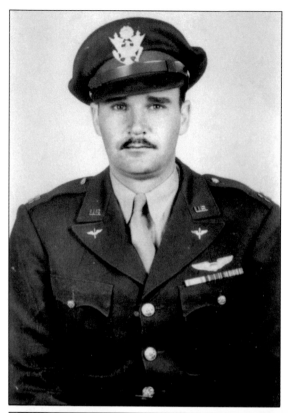

The 429th Squadron commander was 24-year-old Capt. Burl E. Glass Jr., who was given command on August 1, 1943, at the Grand Central Air Terminal in Glendale, California. The initial location assigned to this new squadron under the 474th Fighter Group was the Van Nuys Army Air Field on October 11, 1943. The transfer to Lomita was effective January 4, 1944. (Courtesy Burl Glass.)

Engineering officer Lt. George Patik, of the 429th, was responsible for aircraft maintenance. Note the very minimal furnishings and the EE-8 field telephone with its hand-cranked ringer, used widely throughout the military. (Courtesy Juanita Glass.)

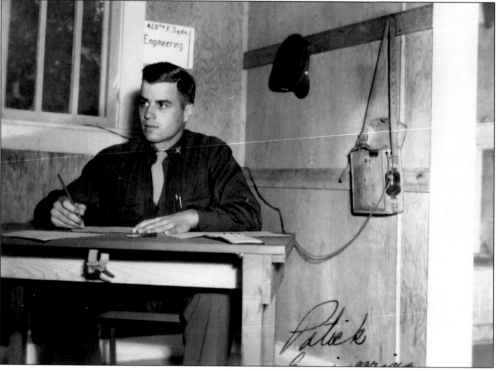

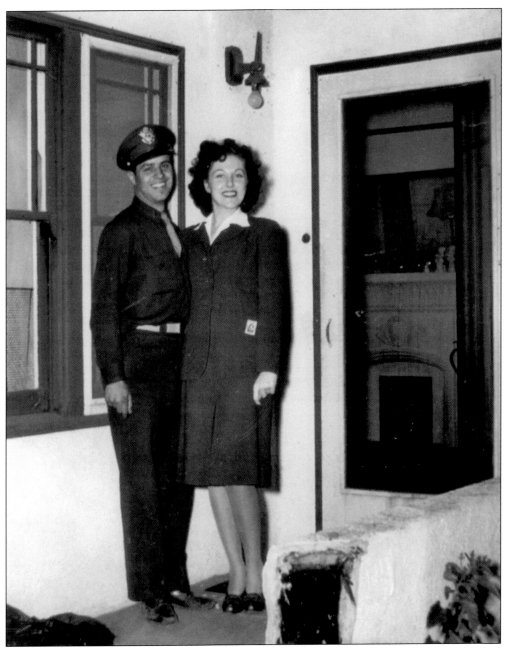

One of the more heartwarming stories of the Lomita Flight Strip was the romance between 2nd Lt. George Patik and Lorraine Mettler. On January 17, 1944, a P-38 crashed in the 1900 block of 253rd Street in Lomita. While George was investigating the crash, Lorraine (Narbonne High School, class of 1941) was returning from work. Their eyes met and love was instantaneous. The photographer saw it and asked them to pose for this photograph on her porch. They dated seven times before George shipped out to England on February 5. He sent daily letters from Europe until the war's end. George and Lorraine were married on June 25, 1946, at St. Margaret Mary's Church, just a few blocks from the crash site. Today their four children have blessed them with nine grandchildren and three great-grandchildren. (Courtesy George Patik.)

On February 5, 1944, the 429th was bused to Hancock Field at Santa Maria for a five-day train ride to Camp Miles Standish in Taunton, Massachusetts. On February 15, 1944, the 429th departed for the Warmwell Airdrome in England, becoming operational with the 9th Air Force on March 12, 1944. By August 1, they had moved to Kings Cliffe, followed by subsequent moves to bases in France and Belgium. As the tactical 9th Air Force followed the advancing Allied armies, the unit relocated to Langensalza, Germany. (Courtesy George Patik.)

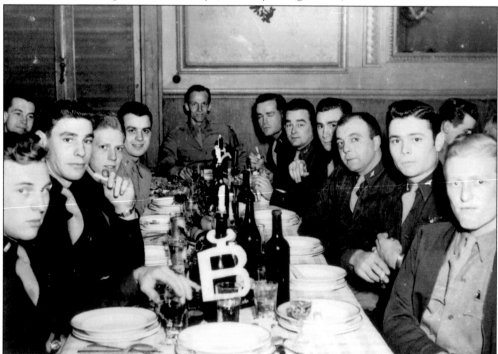

It was a very happy bunch of 429th pilots celebrating the end of the war by throwing a lavish feast in a dining hall in Belgium, reportedly including two bottles of wine each. Lts. George Edmonds, Malcolm Henry, and Milton Graham remained in the service, with each eventually reaching the rank of brigadier general. (Courtesy George Patik.)

THE WHITE HOUSE

WASHINGTON

August 16, 1989

As a former combat pilot, I am honored to offer my
warmest greetings to all those gathered in Colorado
Springs, Colorado, for the Reunion of the 474th Fighter
Group Association.

Your legend involves some of the best leaders, pilots,
mechanics, and campaigns in the history of World War II
aviation. The heroic exploits of the members of the
474th resulted in its becoming one of the most heavily
decorated groups in World War II.

Starting with the D-Day invasion of France, and ending
at Langensalza, Germany, the 474th's P-38 Lightnings
lit up the skies of Europe with victory after victory.
Each of you can take great pride in knowing that your
service significantly contributed toward ending that
terrible conflict.

I join you in tribute to those valiant young men who
gave their lives so that others might live in freedom.
The memorial plaque you are dedicating to them at the
Air Force Academy Cemetery will help ensure that the
sacrifices they made will not be forgotten. I salute
you for your service to our great Nation.

You have my best wishes for a most enjoyable reunion.
God bless you, and God bless America.

George Bush

The 474th Fighter Group was very proud of this presidential commendation from Pres. George
H. W. Bush, dated August 16, 1989. (Courtesy George Patik.)

479th FIGHTER GROUP
February-March 1944

On the heels of the 429th Fighter Squadron's departure from Lomita on February 5, 1944, the 479th Fighter Group headquarters left the Grand Central Air Terminal and moved in promptly on February 6. (Courtesy Fred Hayner.)

The 479th Fighter Group commander was Lt. Col. Kyle L. Riddle, a career officer who had been assigned to the defense of the Panama Canal Zone, flying patrols in the Bell P-39 "Airacobra." (Courtesy Fred Hayner.)

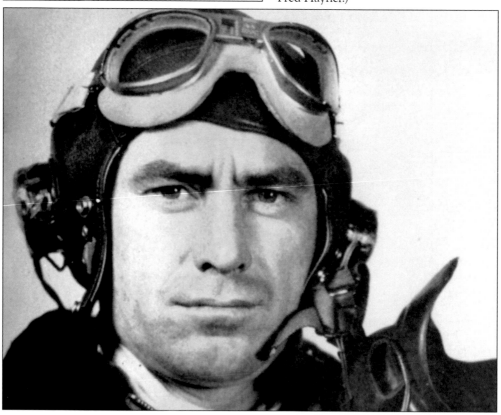

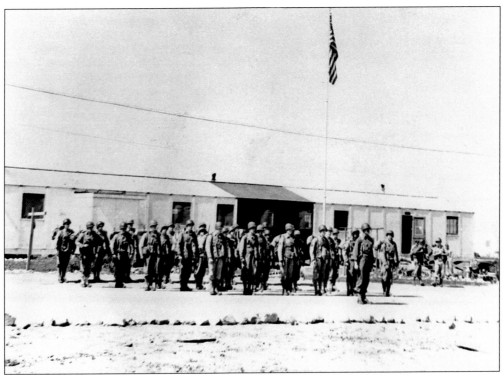

Group headquarters participated in base activities on March 7, 1944, as they formed up with full field packs for a six-mile hike into the Palos Verdes wilderness and an overnight bivouac (see pages 43–44). (Courtesy Air Force Historical Research Agency.)

The 434th Fighter Squadron also moved from Grand Central to the Lomita Flight Strip on February 5, 1944, to find 16 well-worn P-38s, an L-6, two BT-13As, and a B-26 used to tow aerial targets. S.Sgt. Fred Hayner, an aircraft mechanic, designed the 434th insignia. The Germans had named the P-38 the "Fork-Tailed Devil," so Fred picked up that theme, and it remains in use today with the current 434th Tactical Fighter Training Squadron. (Courtesy Fred Hayner.)

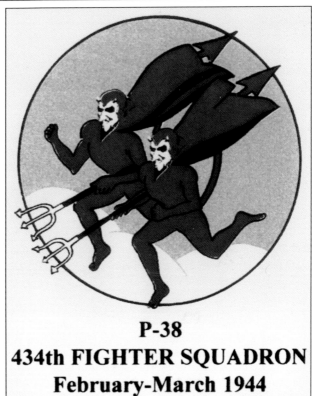

P-38
434th FIGHTER SQUADRON
February-March 1944

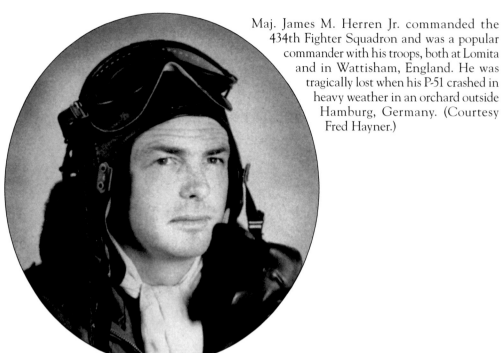

Maj. James M. Herren Jr. commanded the 434th Fighter Squadron and was a popular commander with his troops, both at Lomita and in Wattisham, England. He was tragically lost when his P-51 crashed in heavy weather in an orchard outside Hamburg, Germany. (Courtesy Fred Hayner.)

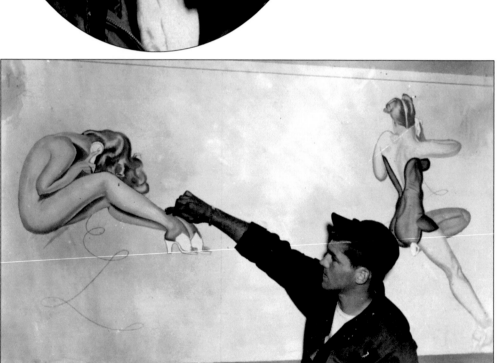

S.Sgt. Fred Hayner, with pastel chalk, embellished the Lomita Officer's Mess with two Petty girls. On the right is the famous *Memphis Belle*, the first B-17 bomber to complete 25 missions in Europe and return to the states for a war-bond tour. S.Sgt. Hayner, also known as "Hayner the Painter," designed the squadron insignia and nose art, becoming a commercial artist after the war. He supplied much of the squadron information and photographs for this book. (Courtesy Fred Hayner.)

Lt. C. Van Anderson, 434th engineering officer (left), is seen with pilot Lt. Robin Olds, who became a standout in the squadron with 13 aerial victories in Europe. He added four more in the Vietnam War, earning the Air Medal with 39 Oak Leaf Clusters, the Distinguished Flying Cross with four Oak Leaf Clusters, the Silver Star with three Oak Leaf Clusters, the British Distinguished Flying Cross, and the French Croix de Guerre. (Courtesy Air Force Historical Research Agency.)

Lt. Robin Olds is depicted with one of the tired P-38G models at Lomita. The large "351" number on the engine nacelle was to make identification easier from the ground since the frisky 19-year-old pilots frequently found sunbathers on the beaches worthy of low-level buzzing. (Courtesy Fred Hayner.)

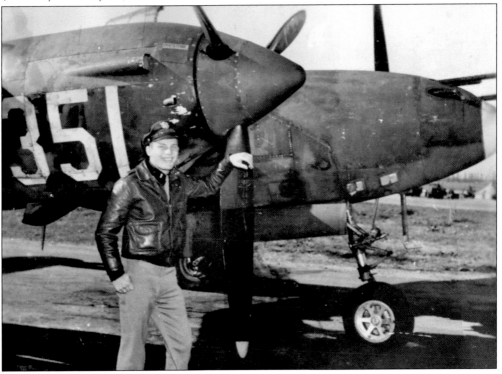

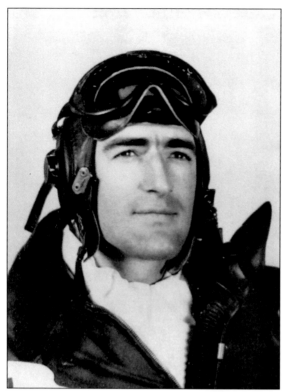

Top ace of the 434th was Lt. Arthur Jeffrey, with 14 aerial victories in Europe in both his P-38 "Boomerang" and P-51 "Boomerang Jr." Never shot down himself, Lieutenant Jeffrey was the leader of "C" flight while at Lomita. After the war, he remained in the service, eventually reaching the rank of full colonel. He retired to his home in Ballwin, Missouri. (Courtesy Fred Hayner.)

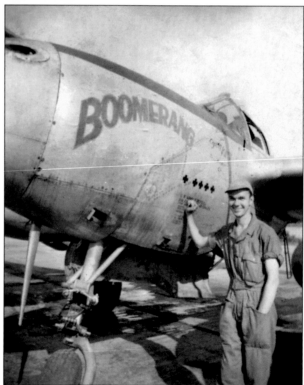

Crew chief T.Sgt. N. C. "Monte" Hummel saw to it that "Boomerang," Art Jeffrey's P-38, was always in top condition for combat. (Courtesy Fred Hayner.)

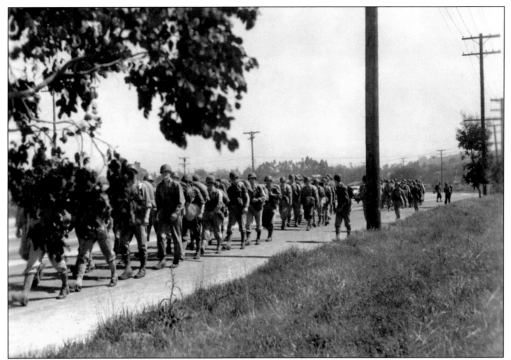

On March 7, 1944, the 479th Fighter Group headquarters and most of the 434th Fighter Squadron hiked six miles up the hill into the Palos Verdes wilderness, set up a camouflaged tent bivouac overnight, then returned to base the following day. (Courtesy Flamm "Dee" Harper.)

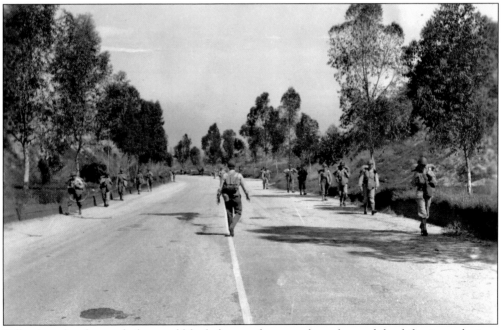

Following what few roads they could find, the squadron members observed the defensive technique of walking along the road edges to allow dispersing into the trees on both sides in case of a strafing attack. (Courtesy Flamm "Dee" Harper.)

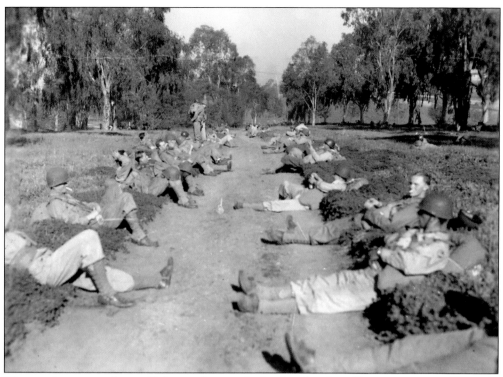

The squadron pauses for a well-deserved rest as the hard-surfaced road began to narrow. (Courtesy Flamm "Dee" Harper.)

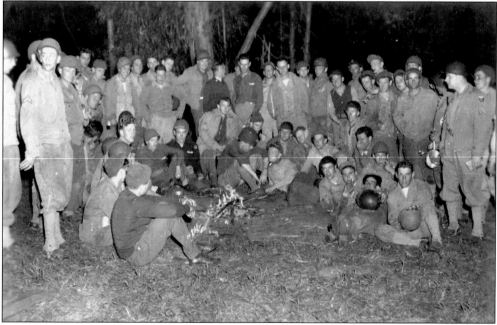

That evening, gathered around a campfire, Lieutenant Evans strummed his guitar for an old-fashioned sing-along with tearful cowboy ballads, while T.Sgt. Guisiano taught an expensive lesson in crapshooting to his fellow soldiers. (Courtesy Flamm "Dee" Harper.)

First Lt. Walter Drake appears ready for combat, which included four aerial victories, the Air Medal with five Oak Leaf Clusters, and the Distinguished Flying Cross. Walt currently lives in Corona del Mar in Orange County, California, and served as consultant for much of the 434th Fighter Squadron's history. (Courtesy Walter Drake.)

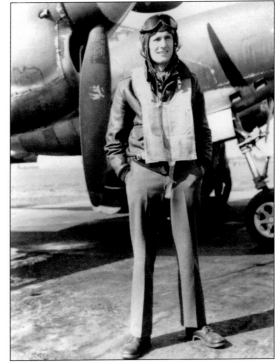

First Lt. Richard G. Simpson is pictured with his crew chief and aircraft mechanic. Lt. Simpson was awarded the Air Medal with six Oak Leaf Clusters, the Distinguished Flying Cross, and the Purple Heart. (Courtesy Air Force Historical Research Agency.)

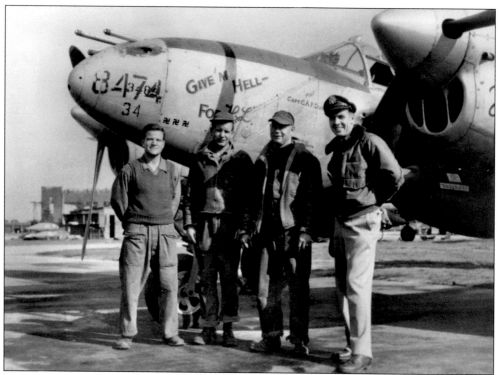

Capt. Claire A. P. Duffie, right, is seen with his crew chief, armorer, and aircraft mechanic. Note the nose art and swastikas denoting aerial victories. Duffie's impressive combat awards included the Air Medal with 17 Oak Leaf Clusters, the Silver Star with an Oak Leaf Cluster, and the Distinguished Flying Cross. (Courtesy Air Force Historical Research Agency.)

First Lt. Thomas D. Neeley destroyed six enemy aircraft and was awarded the Air Medal with 11 Oak Leaf Clusters and the Distinguished Flying Cross. (Courtesy Air Force Historical Research Agency.)

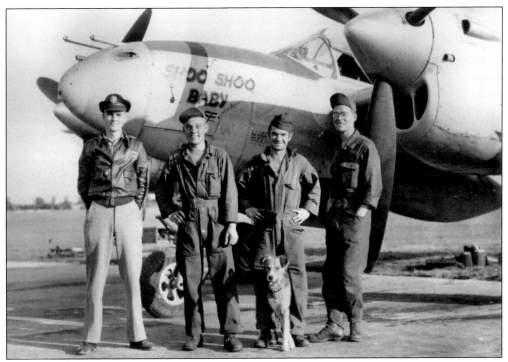

First Lt. John N. Morrow is depicted with his crew chief, armorer, and aircraft mechanic. He earned the Air Medal, nine Oak Leaf Clusters, and the Distinguished Flying Cross. (Courtesy Air Force Historical Research Agency.)

First Lt. John T. Tipps is seen with his crew chief. After the war, Tipps entered politics and became a state senator in Oklahoma. In combat, he earned the Air Medal with five Oak Leaf Clusters and the Distinguished Flying Cross. (Courtesy Air Force Historical Research Agency.)

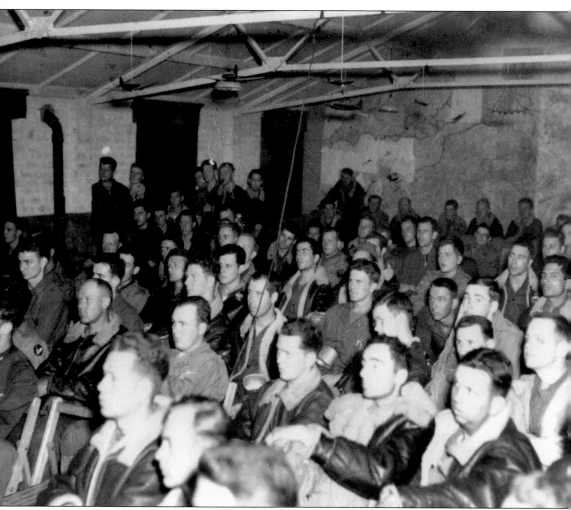

The 434th Squadron's commander, James Herren, conducted a mock briefing for his enlisted personnel to experience firsthand what pilot mission briefings were like. The 434th arrived in England in May 1944, the last squadron to join the 8th Air Force. Missions were flown daily, escorting B-17 and B-24 heavy bombers, conducting fighter sweeps, and attacking anything on the ground that moved—usually truck convoys, trains, and airfields. (Courtesy Air Force Historical Research Agency.)

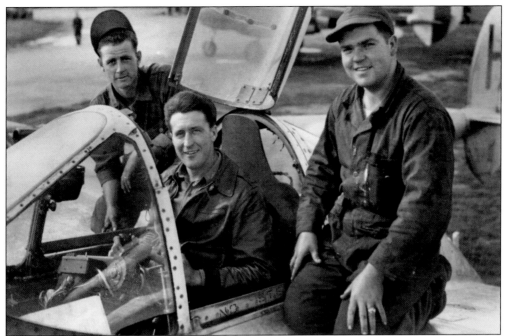

Capt. George Gleason, smiling with his ground crew, Sergeant Coakley, left, and Staff Sergeant Perdue. George claimed 12 aerial victories and the squadron's 28-second landing record. He would buzz the runway, then pull up sharply and turn 180-degrees back to the approach end of the runway while extending landing gear and flaps. Only one other pilot challenged George's record, but he was badly burned when his plane cartwheeled down the runway. (Courtesy Air Force Historical Research Agency.)

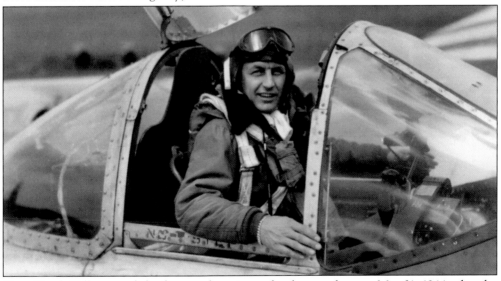

Capt. Frank Keller scored the first combat victory for the squadron on May 31, 1944, when he strafed an enemy airfield in France. Most planes were out of fuel, but a Junkers JU-88 at the end of the flight line caught fire and exploded. Frank flew through the explosion, badly nicking his propellers. He later was shot down and spent the remainder of the war as a POW. (Courtesy Air Force Historical Research Agency.)

The Officer's Club at Wattisham Airfield in Suffolk County, east of London, provided warm, comfortable quarters for 479th Fighter Group pilots in the finest English tradition. (Courtesy Air Force Historical Research Agency.)

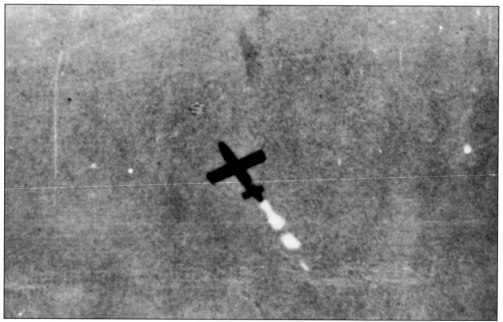

Late in the war, the Germans attempted to demoralize the British by launching unguided, explosive-laden, pilotless aircraft against British cities from German launch sites across the English Channel. Powered by a pulse jet engine, these V1 "buzz bombs" flew in an unguided straight line until running out of fuel. That means as long as the pop-pop-pop of the engine was heard, it was safe on the ground directly beneath. (Courtesy George Patik.)

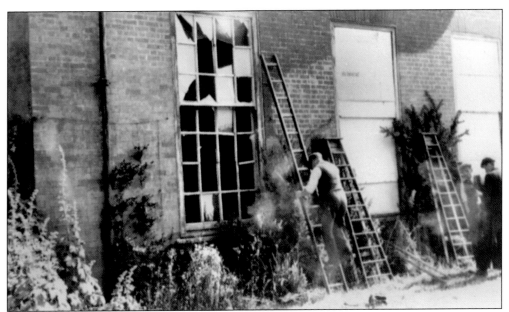

On the night of June 19, 1944, a B-17 trying to land bellied in around 600 yards from the Wattisham Officer's Club. Sightseers gathered to watch it burn but scattered quickly when the crew explained it had a full load of bombs. After the inevitable explosion, the squadron log reported the concussion left "the front of the Officer's Club . . . completely ventilated." (Courtesy Air Force Historical Research Agency.)

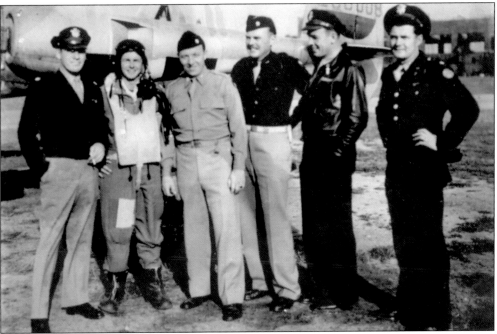

Returning from a mission, Major Herren, the 434th commander, was greeted by his staff with the news that he had been promoted to lieutenant colonel. Pictured here, from left to right, are Sidney Woods, Colonel Herren, Bill Stenten, Frank Silver, Capt. Claire Duffie, and Dr. William McElhinney. In the background is Colonel Herren's P-38. (Courtesy Fred Hayner.)

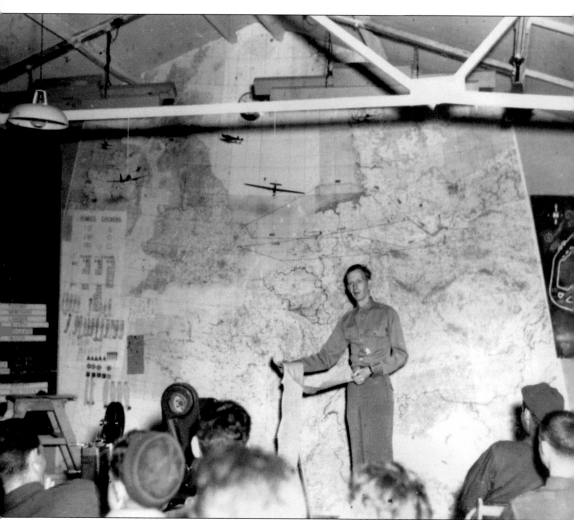

Briefing officer Lt. Donald Horton typically scheduled mission briefings to "smack the Hun" in the wee hours of the morning. The large wall map indicates flight paths from Wattisham to various points in Northern Germany. On D-Day, June 6, 1944, the 434th pilots arose at 3:30 a.m. for missions that were scheduled until 11:00 that evening. (Courtesy Air Force Historical Research Agency).

ZZ Almond Ranch,
1056 Mt Ida Road,
Oroville, Ca. 95960

14 August 1994

Charles Lobb,
Chairman,
Torrance Air Fair Assoc.,
Box 505, Torrance, California

Dear Mr Lobb : ——————

It is with sincere regrete that I must inform you — that because of previous commitments with guests from Europe & business meetings — I am unable to accept your invitation to attend your Torrance Air Fare —— 22 & 23 Oct 94.

Wishing you success in your venture — and hoping you round up some 479th Fighter Group pilots.

Sincerely
Hub Zemke
Col., U.S.A.F.

In 1994, after retirement in Northern California, 479th Fighter Group commander Col. Hubert "Hub" Zemke was invited to the Torrance Air Fair to celebrate the 50th anniversary of D-Day. He regretfully declined and passed away just a few months later. This letter is believed to be one of the last examples of the personal handwriting of the leader of the famous "Wolf Pack," the 56th Fighter Group in Italy. Colonel Zemke was transferred to the 479th Fighter Group at Wattisham when Col. Kyle Riddle failed to return from a mission over France.

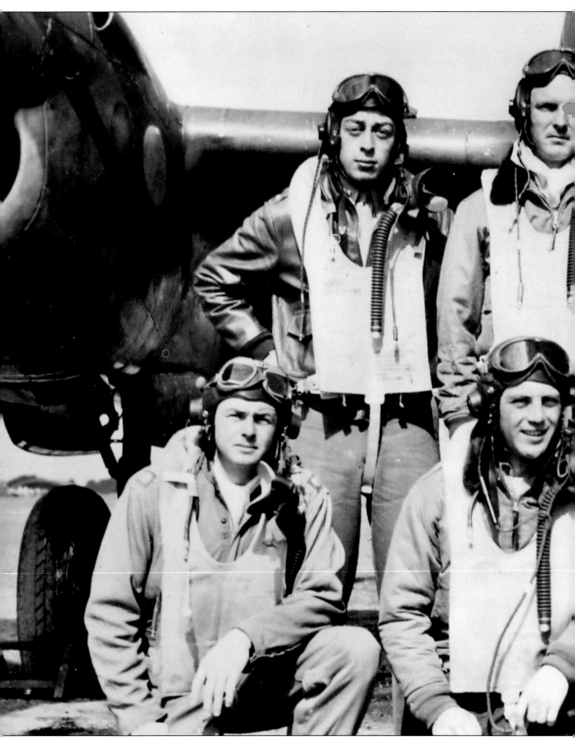

Fresh from an engagement over France that netted 32 enemy aircraft destroyed, this group of outstanding 479th Fighter Group pilots assembled for this photograph. Pictured here, from left to right, are (first row) Lt. Col. James Herren, Col. "Hub" Zemke, Lt. George Gleason, and Lt. George

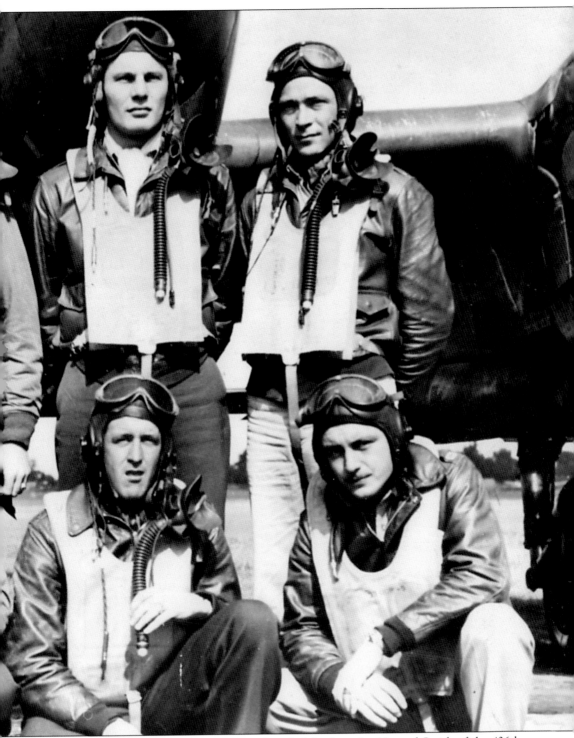

Sykes; and (second row) Lt. Robert Pigg, unidentified (perhaps Lt. Howard Smith of the 436th FS), Capt. Robin Olds, and Lt. Tom Olson. This photograph is also included in the World War II collection of the Wattisham Royal Air Force Museum in England. (Courtesy Fred Hayner.)

HEADQUARTERS EIGHTH AIR FORCE
OFFICE OF THE COMMANDING GENERAL
APO 634

GENERAL ORDERS 15 July 1945
NUMBER 117

CITATION

THE 479th Fighter Group, is cited for extraordinary heroism and superior performance of duty in aerial conflict with the enemy, 18 August 1944 and 5 and 26 September 1944. On 18 August 1944, the Group voluntarily, and with complete disregard for the purported impregnable ground defenses, strafed the Nancy-Essey airfield until smoke from burning aircraft completely obliterated the target. The attack was pressed home with such vigor and tenacity of purpose that forty-three (43) enemy planes were destroyed and twenty-eight (28) damaged with the loss of only one (1) pilot and plane. On 5 September 1944, after an arduous bombing and strafing mission against three (3) major enemy airfields, the 479th Fighter Group requested and received permission to attack four (4) important airdromes where it was known the defenses would be both alert and vicious. Immediately upon returning to base, the men of this stalwart unit, without rest or relaxation, meticulously planned, mapped, and then completed their second mission within twenty-four (24) hours. The fact that victories for the day totalled fifty-two (52) enemy aircraft destroyed and thirty (30) damaged, as against the loss of one (1) pilot and plane, is a tribute to the dexterity and proficiency of both the air and ground echelons of the Group. Soon after this exceptional display of initiative, and during conversion from P-38 fighters to the radically different P-51's the Group defied the complexities of operating both types together and on 26 September 1944 engaged forty (40) hostile fighters airborne near Munster. In the ensuing battle, one (1) pilot and plane were lost to the Group, while the enemy suffered twenty-nine (29) aircraft destroyed and seven (7) damaged. By the extraordinary heroism, professional skill, and determination of the combat pilots, together with the outstanding technical ability and devotion to duty of the ground personnel, the 479th Fighter Group, on each of these dates, played a major role in dealing the much vaunted German Air Force devastating blows from which it never completely recovered. The unexcelled spirit of cooperation and perseverance displayed by all members of the 479th Fighter Group in their relentless prosecution of the aerial offensive to the utmost exemplify the finest traditions of the Armed Forces of the United States.

BY COMMAND OF MAJOR GENERAL LARSON:

EMIL C. KIEL,
Brigadier General, U. S. A.,
Chief of Staff

OFFICIAL:
Lindsy L. Braxton,
Colonel, A.G.D.,
Adjutant General

On July 15, 1945, the 479th Fighter Group was awarded the Distinguished Unit Citation from headquarters, 8th Air Force, for outstanding accomplishments during the missions of August 18, 1944, September 5, 1944, and September 26, 1944. These three missions resulted in the destruction of 124 enemy aircraft and 65 damaged while losing only two pilots and planes. (Courtesy Fred Hayner.)

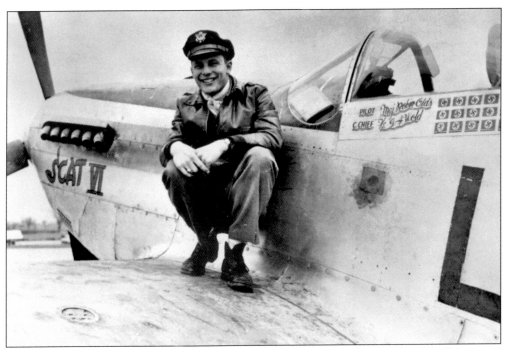

In September 1944, the 479th Fighter Group transitioned to the North American P-51 "Mustang." Maj. Robin Olds increased his aerial victories to 13 by the war's end. He continued to serve with North Atlantic Treaty Organization Forces, eventually transferring to the former South Vietnam where he flew the F-4 "Phantom" and shot down four enemy MIG-21s. He is believed to be the only fighter pilot to have scored combat victories in both World War II and Vietnam. (Courtesy Fred Hayner.)

Maj. Arthur Jeffrey flew his P-51 "Boomerang Jr." to 10 aerial victories after the four he racked up flying his P-38J "Boomerang." His total of 14 victories was tops for the 434th Fighter Squadron and the 479th Fighter Group and included a rocket-powered Messerschmitt Me163 "Komet." His awards include the Air Medal with 16 Oak Leaf Clusters, the Distinguished Flying Cross with an Oak Leaf Cluster, and the Silver Star. (Courtesy Fred Hayner.)

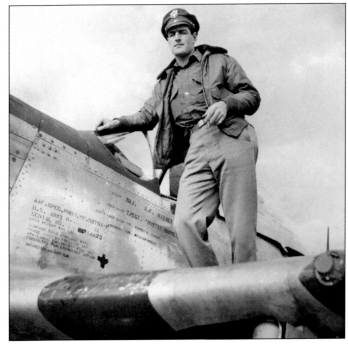

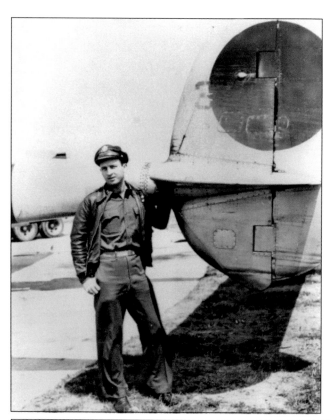

Capt. Joseph E. Stroop of the 434th Fighter Squadron is pictured here. The red ball on the tail of his P-38 was the official squadron marking for the 434th. (Courtesy Air Force Historical Research Agency.)

First Lt. Robert H. Hendrickson poses on his P-38 with his ground-support crew. His combat record included four enemy aircraft destroyed, two damaged, the Air Medal with eight Oak Leaf Clusters, and the Distinguished Flying Cross. (Courtesy Air Force Historical Research Agency.)

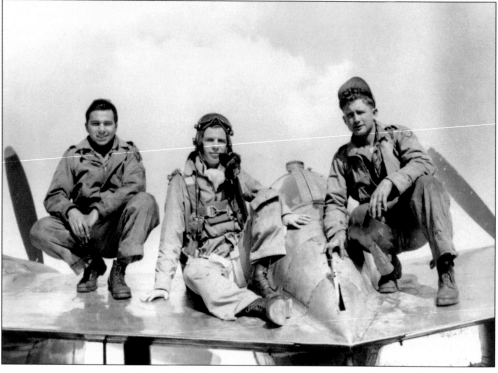

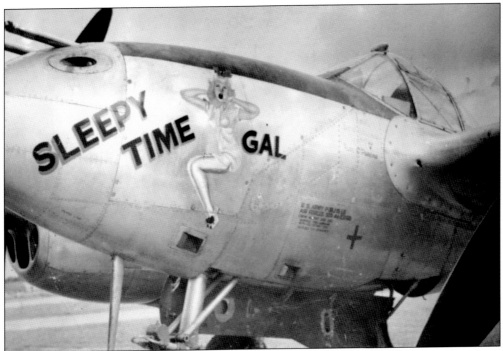

Fred Hayner, "Hayner the Painter," was very proud of this example of his nose-art talent from Wattisham, England, in 1944. (Courtesy Fred Hayner.)

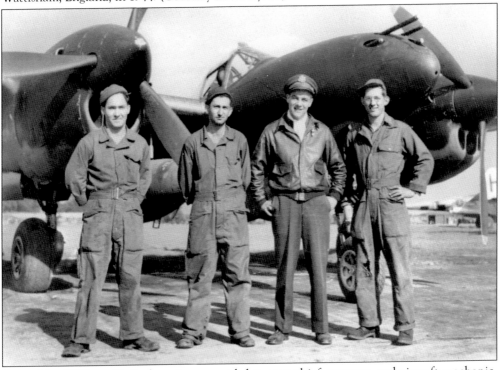

Second Lt. William H. Rodgers is seen with his crew chief, armorer, and aircraft mechanic. (Courtesy Air Force Historical Research Agency.)

This insignia represents the 6th Ferrying Group of the Air Transport Command. By August 1944, with no additional fighter squadrons being formed, the 4th Air Force transferred the Lomita Flight Strip to the 6th Ferrying Group, based at the Long Beach Army Air Field. Warbirds manufactured by Douglas, Lockheed, North American, Northrop, and Vultee were delivered to Long Beach throughout the war; seven squadrons of 1,700 pilots delivered them around the world. (Courtesy Barbara London.)

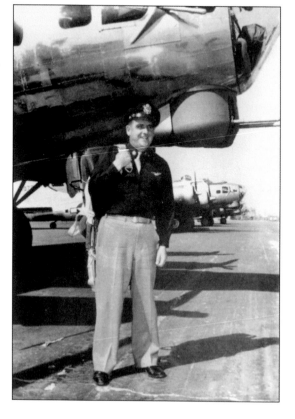

Commander of the 6th Ferrying Group, Col. Andrew B. Cannon, remained on active duty throughout World War II. In 1951, he was recalled to active duty and has logged over 20,000 hours and flown more than 4 million air miles, piloting many types of aircraft. He was promoted to brigadier general in May 1960. (Courtesy Barbara London.)

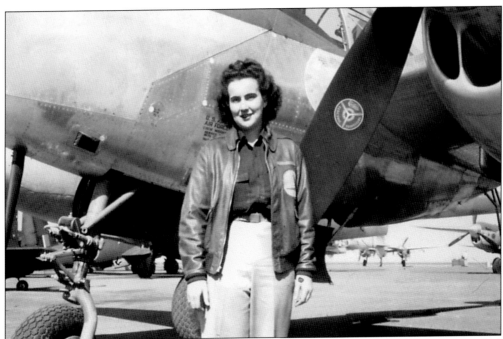

Commander of the WASP Squadron at Long Beach was Barbara Erickson. Barbara was checked out to fly anything with one to four engines and had accumulated over 400 hours flying time before the war. The Women's Auxiliary Service Pilots (WASP) ferried virtually every type of warbird to bases across the United States. Barbara remained at Long Beach after the war, running her own flying service. (Courtesy Barbara London.)

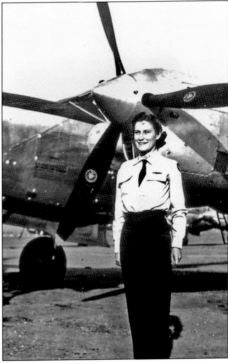

A native of Redondo Beach, California, Iris Cummings flew with the WASP squadron of the 6th Ferrying Group. As the war progressed so did neighborhood noise complaints around Long Beach Army Air Field. Air traffic at Long Beach eventually became dense enough to send aircraft to the Lomita Flight Strip, where air traffic was more manageable. By late 1944, landings and takeoffs reached 2,500 to 3,500 per month at Lomita, keeping tower personnel busy. (See pages 70–72). (Courtesy Iris Critchell.)

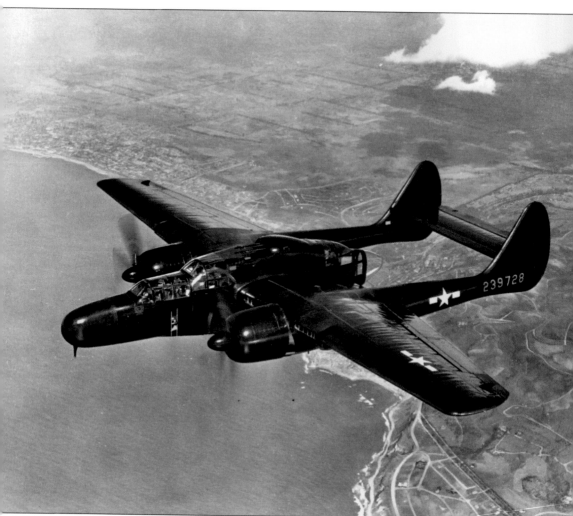

The Northrop P-61 "Black Widow" was fitted with two Pratt and Whitney 2,100-horsepower engines. The first aircraft that was designed specifically as a night fighter, it was ferried around the country by WASP pilots. Armed with four .50-caliber machine guns in an upper turret and four 20-mm cannons in the belly, it could also carry a bomb load of 6,400 pounds. Note the coastline of the Palos Verdes Peninsula, Torrance, and Redondo Beach. (Photograph by Ray Wolford; courtesy Iris Critchell.)

Three

THE POSTWAR YEARS

In the months following September 1945, when Lomita Flight Strip was declared surplus, a blizzard of federal paperwork decided its fate along with many other wartime installations in the U.S. The War Assets Administration (WAA) struggled to determine who owned what. In October, the War Relocation Authority usurped the barracks and added trailers to house Japanese Americans returning from internment camps. The Third Region Civil Air Patrol (CAP) claimed they should inherit the field since the commander of the 6th Ferrying Group had issued them a Conditional Use permit. Surreptitiously Roger Keeney opened his Acme Aircraft Company for business in the large maintenance hangar (see Chapter 4). Former owner Ben Weston was offered the property, but he indicated no interest unless it was returned to its prewar agricultural condition. His request was denied, and Ben lost interest.

Throughout 1946, the WAA continued attempts to properly dispose of the 490 acres. Finally on December 7, the City of Torrance was issued a permit to use the runway. One month later, the WAA issued an interim permit for the city to use the entire installation.

In September 1947, the Secretary of War issued an interim license to the city, retroactive to May 28, 1947. On March 28, 1948, 30 months after the end of World War II, the WAA issued a Quitclaim Deed to Torrance with five pages of caveats, conditions, and restrictions that the property remain an airport and that the government retain the right to reclaim it at any time and drill for oil or mine strategic radioactive materials (thorium and uranium were specifically mentioned).

The City of Torrance formally released their first Airport Master Plan on October 13, 1948, and were off and running with their new acquisition. Growth began slowly with a few aviation-related businesses along the flight line. Crenshaw Boulevard was extended south, bending around the end of the runway and across Pacific Coast Highway. Retail businesses sprouted up on both sides of Crenshaw with long-term leases from the city. The Bay Cities Airport in north Torrance, sometimes called the Torrance Airport or Torrance Community Airport, succumbed to the pressure for residential housing, thus ending the confusion of airport names.

On September 19, 1945, the Lomita Flight Strip was officially declared surplus by teletype No. 7888 from the Office of the Chief of Engineers. The 6th Ferrying Group officially closed the field at 1:00 p.m. on September 28, 1945. Sergeants Fenton and Schneider of the 101st Army Airways Communications System began removing radio equipment from the tower. Only a few aircraft of the Third Region Civil Air Patrol remained. The field looked tired, alone, and abandoned. (Courtesy Bill Switzer.)

```
                          UNITED STATES

                    DEPARTMENT OF THE INTERIOR
                     WAR RELOCATION AUTHORITY
                         461 Market Street
                         Sheldon Building
                      San Francisco 5, California

                                            September 21, 1945.

Division Engineer
Pacific Division
U. S. Army Engineers
351 California Street
San Francisco, California

Attention:   Colonel Ellingson

Dear Colonel Ellingson:

          Yesterday your office informed me that the Lomita Flight
Strip, located at Lomita, California, had been declared surplus to Army
needs.  It is my understanding that there is housing for approximately
four to five hundred people on this installation and that the buildings,
·as well as the real estate, are Government-owned.

          I would appreciate it if you would take immediate steps to grant
the War Relocation Authority permission to use this installation for the
housing of returning evacuees.  The overall authority for granting
such a permit is contained in the letter of September 10 to Abe Fortas,
Under Secretary of The Interior, from Robert P. Patterson, Under Secretary
of War.

          As we are faced with an emergency situation in Los Angeles
County, I would appreciate anything which you can do to speed up the
granting of this permit.

                              Sincerely yours,

                              /s/ H. Rex Lee, Acting Chief
                                  Relocation Division
```

Little interest was shown in the runway, but letters poured in requesting the buildings. The War Relocation Authority needed immediate permission to house Japanese Americans returning from internment centers. The request was granted, and by December 1945, families began filling the barracks and 85 temporary trailers. Ownership questions were resolved when it was determined the Federal Works Agency owned the runway while the War Assets Administration owned everything else. (Courtesy National Archives-Pacific Southwest Region, Laguna Niguel, California.)

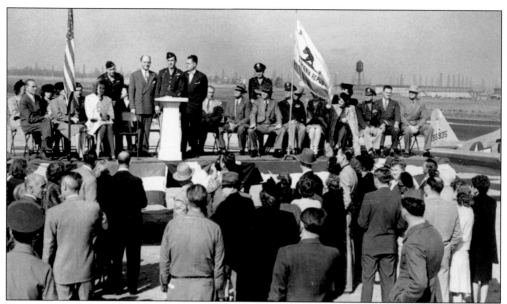

On December 7, 1946, in a colorful ceremony, the City of Torrance named the field Zamperini Field in honor of hometown hero Capt. Louis Zamperini (see Chapter 6). The Civil Air Patrol and Acme Aircraft (see Chapter 4) had been keeping the airport alive. On November 18, 1946, the Commissioner of Public Roads issued Torrance a "Revocable Permit to State or Local Government Unit for Use of Flight Strip Property," allowing the city to use the runway. (Courtesy Louis Zamperini.)

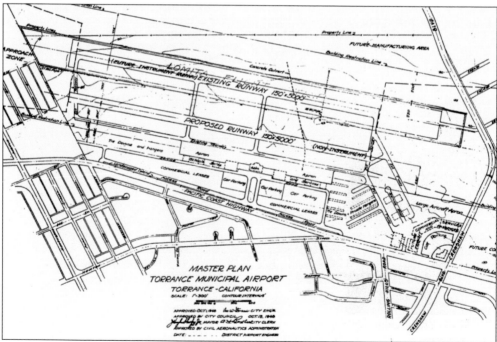

By October 13, 1948, the Torrance City Council had approved the first Airport Master Plan, envisioning the Crenshaw Boulevard extension, a second runway, new taxiways, and commercial zoning along Pacific Coast Highway. (Courtesy City of Torrance.)

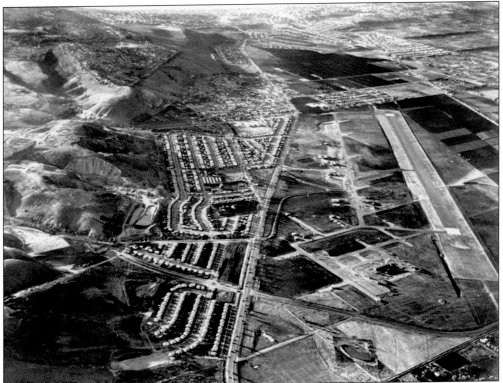

Soldiers returning from the war needed low-cost housing. The Walteria area south of Pacific Coast Highway quickly filled with low-cost, single-family homes. Crenshaw Boulevard was extended around the end of the runway and across PCH, taking out the last remnants of wartime's wooden barracks. Only the P-38 hardstands and the maintenance hanger housing Acme Aircraft remained. Seasonal Walteria Lake (dark area at the top) remained agricultural. (Courtesy Bill Switzer.)

This Waco YKS-7 cabin biplane may have belonged to actor Wallace Beery. In the background is the last remaining P-38 on the field. Little used—it only had four flying hours on it—this P-38 was taken by the army and dismantled for scrap. However Roger Keeney of Acme Aircraft was able to drain the precious ethylene glycol coolant from the engines when the disposal crew took their lunch break. (Courtesy Roger Keeney.)

In July 1947, both the *Los Angeles Times* and *Los Angeles Examiner* ran classified advertisements placed by the War Assets Administration for disposal of the Lomita Flight Strip. The land, runways, buildings, and furnishings were offered, in the following order, to: federal government agencies, the Reconstruction Finance Corporation (for resale to small businesses), state and local governments, and non-profit institutions. (Courtesy National Archives-Pacific Southwest Region, Laguna Niguel, California.)

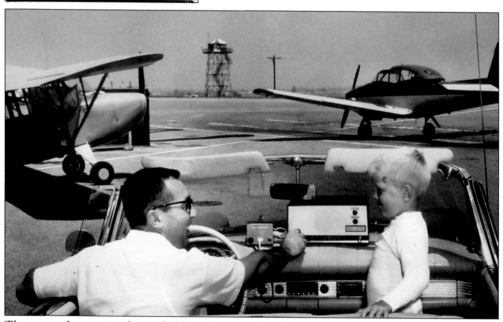

The control tower in the mid-1950s, along with a Aeronca C-3 (left) and a popular North American Navion (right), flank a Ford convertible monitoring aircraft radio traffic. The Navion was produced in anticipation of a private flying boom similar to the spurt following World War I. (Courtesy City of Torrance.)

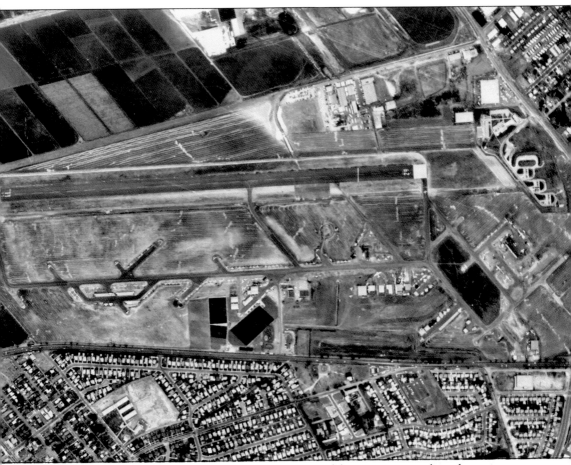

By 1958, businesses, a flight school or two, and private aircraft began to appear along the taxiways. Note the Nike missile battery (far right), constructed in 1956. Nike Station LA-57 included an administration building and four underground missile storage bunkers behind an embankment along Crenshaw Boulevard. Controlled from a radar site at Wilderness Park in Redondo Beach, Nikes would be erected and launched should hostile aircraft penetrate the U.S. air-defense curtain. (Courtesy City of Torrance.)

From 1947 through 1972, annual cross-country races were organized by the Ninety-Nines, a national organization of women pilots. Officially known as the All Women's Transcontinental Air Race (unofficially as the "Powder Puff Derby"), it helped promote aviation careers for women. Iris Cummings Critchell (right), a former WASP at Long Beach AAF, flew this Taylorcraft BC-12D with her 16-year-old student, Nancy Krause. (Courtesy Iris Critchell.)

Iris and Nancy were all smiles during this final walk-around airworthiness inspection of their Taylorcraft in the 1950 Powder Puff Derby. In 1957, Iris and her copilot, Alice Roberts, won the race from San Carlos, California, to North Philadelphia, Pennsylvania. (Courtesy Iris Critchell.)

In 1960, the Powder Puff Derby started at Torrance Municipal Airport and ended at Wilmington, Delaware, with 12 stops along the way. The planning committee, all pilots with hundreds of hours of flying experience, included, from left to right, Mary Pinkney, Margaret Berry, Rita Gibson, and Iris Critchell. (Courtesy Iris Critchell.)

Mary Pinkney owned a sand and gravel business in Walteria, across the road from the Torrance Airport, hence her sponsorship and slogan on their 175-horsepower Cessna 175 in the 1960 race. (Courtesy Iris Critchell.)

Mary and Iris await the starters signal to begin their first leg of the 1960 race from Torrance to Needles, California. In 1967, the race again involved Torrance, this time as the final destination. The ocean-to-ocean, east-to-west race was from Atlantic City, New Jersey, to Torrance Municipal Airport. (Courtesy Iris Critchell.)

In 1963, a five-story Federal Aviation Administration control tower was constructed at the midpoint of both runways, the final phase of the 1948 Master Plan. A second runway, 29L-11R, new field lighting, taxiway enlargement, and eight acres of clear zone on the west end were also added. All remaining vestiges of the old P-38 hardstands disappeared. (Courtesy City of Torrance.)

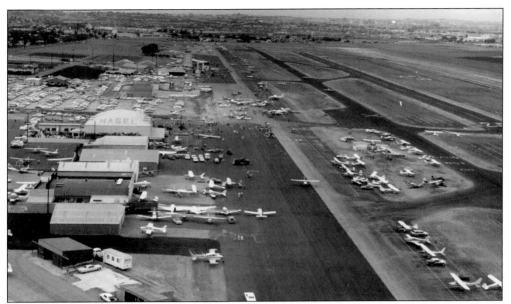

With the field growing steadily, annual air fairs were scheduled beginning in 1958. This westerly view shows the second runway, the new control tower, and growing Fixed Base Operators (FBOs) in the foreground, including the Sperry Air Service and Nagel Aircraft. (Courtesy City of Torrance.)

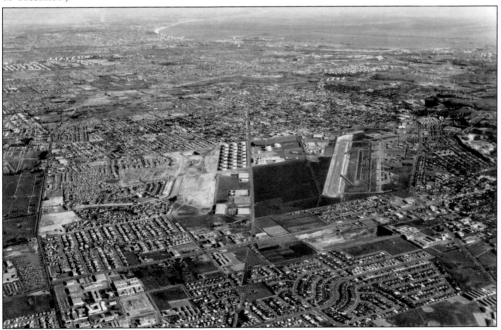

An easterly view on New Year's Day 1965 shows the surrounding residential growth of Torrance, Lomita, and Redondo Beach, while the airport's heritage has been preserved by maintenance of a significant agricultural expanse (left). Note the oil tanks (center) at the corner of Lomita and Crenshaw Boulevards, Bixby Slough (now Harbor Lake), the curve of the shoreline at Long Beach (top), and the Los Angeles and Long Beach Harbors in the distance. (Courtesy City of Torrance.)

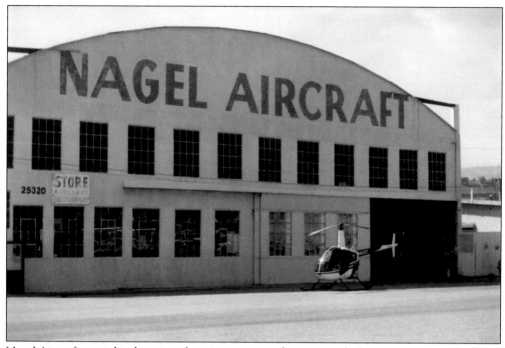

Nagel Aircraft specialized in aircraft maintenance and maintained a large inventory of fuselages, wings, and other aircraft components. (Courtesy City of Torrance.)

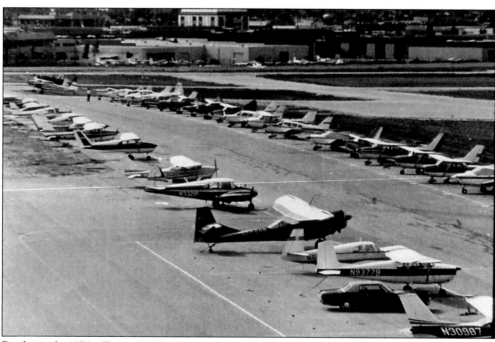

By the early 1970s, Torrance Municipal Airport had reached its zenith. This view of the flight line west of the control tower shows a portion of the 780 aircraft tie-downs with a long waiting list for more. Landings and takeoffs had reached 470,000, making Torrance one of the 12 busiest airports in the nation. (Courtesy City of Torrance.)

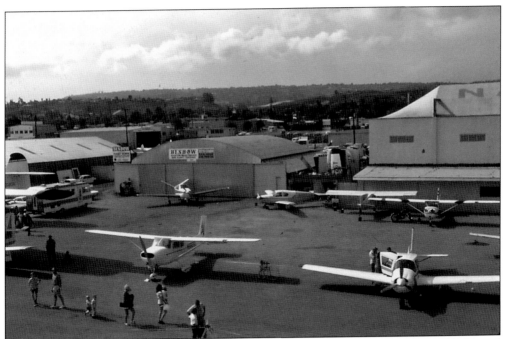

Benbow Aviation, Sperry Air Services, and Nagel Aircraft were three of the 15 FBOs and businesses in the early 1970s. (Courtesy City of Torrance.)

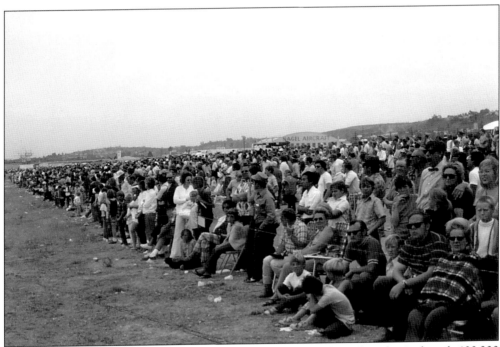

From 1958 through 1972, annual air shows drew enormous crowds, such as this 1 of nearly 100,000 at the 1971 Torrance Air Fair in October. (Courtesy City of Torrance.)

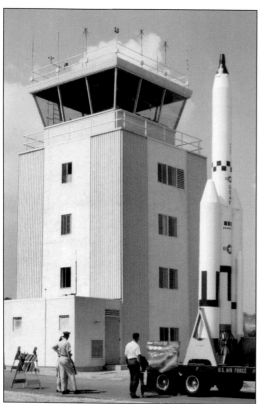

Air fairs frequently included displays from the Southern California aerospace industry, such as this scale model of a Titan III Space Booster, courtesy of the Los Angeles Air Force Base in nearby El Segundo. The control tower (background) was kept busy coordinating performances by the nation's top aerobatic pilots. (Courtesy City of Torrance.)

Aircraft rides were very popular at various Torrance Air Fairs. Local pilots contributed their time and aircraft for "once around the patch" rides, many for children who had never flown before. (Courtesy City of Torrance.)

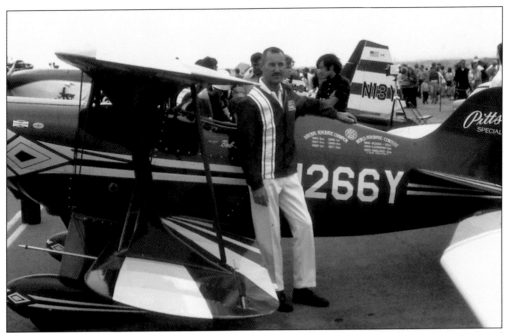

Bob Herendeen, a TWA captain with 30 years flying experience, has also been a national and international aerobatic champion. He parked his bright red Pitts Special biplane at a Torrance Airport hangar. He was famous for holding spectators entranced with his incredible exhibitions of precision aerial maneuvers. (Courtesy City of Torrance.)

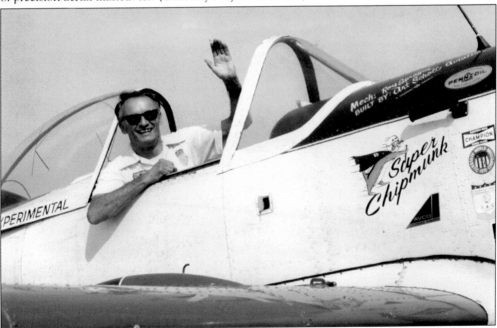

In his Canadian-built "Super Chipmunk," nationally renowned aerobatic pilot Art Scholl conducted his breathtaking performances at Torrance along with such other notables as Mira Slovak, Skip Volk, Mike Dewey, Joe Hughes, and Bob Hoover. Art was head of the Department of Aeronautics at San Bernardino Valley College. (Courtesy City of Torrance.)

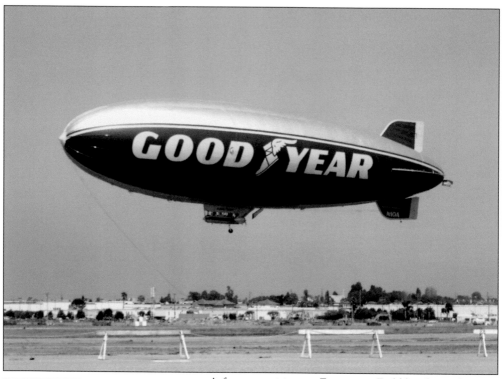

A frequent visitor to Zamperini Field has been the Goodyear blimp *Spirit of America*, based at the nearby Goodyear blimp port in Carson. It is frequently seen both day and night in the skies over Los Angeles, especially over stadiums and outdoor sporting events. The cabin seats six, cruises comfortably at 30 miles per hour, and is powered by two 210-horsepower fuel-injected engines. (Courtesy David Harmon.)

TORRANCE MUNICIPAL AIRPORT

AIRPORT ADMINISTRATION OFFICE
3115 Airport Drive
Torrance, California 90505
(213) 325-0191

AIRPORT OPERATIONS OFFICE
25410 Bellanca Way
Torrance, California 90505
(213) 325-0040

December, 1972

The City of Torrance published a brochure in December 1972 outlining facts and features of the airport—780 based aircraft, 12th busiest airport in the nation in annual takeoffs and landings, 25 aeronautical businesses and facilities on the field, four fuel pits with 80, 100, and 120 octane fuel, public-relations activities, and farming were all listed. Annual takeoffs and landings had reached 470,000 total. (Courtesy City of Torrance.)

Groundbreaking ceremonies for the new General Aviation Center (GAC) were held on May 15, 1991, with completion targeted for 1992. As part of the dedication ceremonies, the open house included local pilots displaying their aircraft on the flight line side of the GAC. It was a cautious start to reopening the annual air fairs. (Courtesy City of Torrance.)

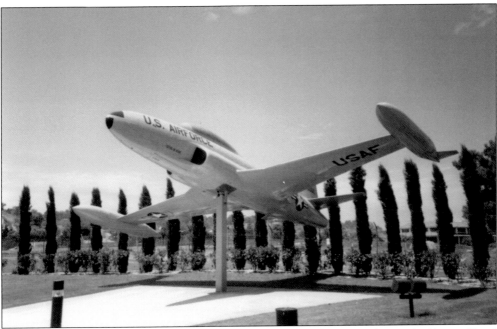

Accompanying the opening of the GAC, Eli Alexander of AlexAir and several of his staff and friends purchased and installed an Air Force T-33 "Shooting Star" on a pedestal in front of the GAC as a gift to the city. (Courtesy City of Torrance.)

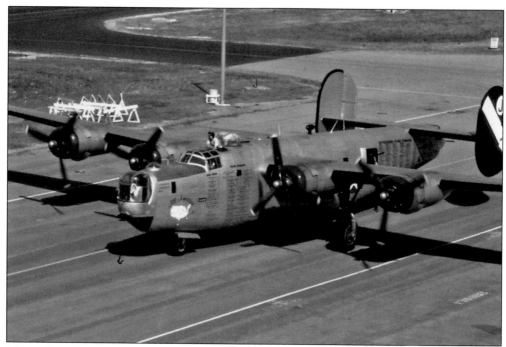

The Collings Foundation of Stow, Massachusetts, frequently included Torrance in their annual "Wings of Freedom" national tour, featuring two fully restored World War II heavy bombers—this Consolidated B-24 "Liberator" and a Boeing B-17 "Flying Fortress." Tours through each aircraft, as well as in-flight experiences, were available to the public. Lou Zamperini stopped by and recalled his experiences as a B-24 bombardier (see Chapter 6). (Courtesy City of Torrance.)

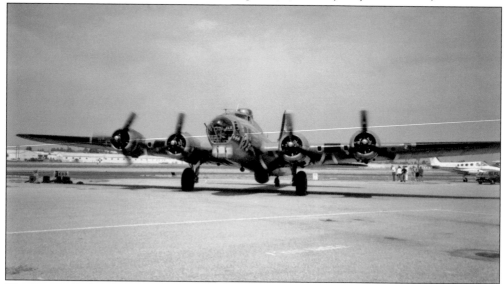

The Boeing B-17 "Flying Fortress" was probably the most widely known and most-publicized bomber of World War II, with 13,000 of them produced for the war effort. Used primarily in the European theatre, "aluminum overcast" missions of 1,000 aircraft were flown against targets in Europe. The B-17G carried a crew of 10 plus a bomb load of 9,600 pounds for a distance of 3,750 miles. (Courtesy City of Torrance.)

Four

AVIATION BUSINESSES

In the early days of aviation in Torrance, one of the most prominent air-related businesses was Doak Aircraft Company. Conceived in 1939 by self-taught engineer and Douglas Aircraft vice president Edmond Rufus Doak Jr., Doak Aircraft Company was clustered in buildings near downtown Torrance from 1940 until the founder's death in 1986. Throughout the war, Doak Aircraft grew to employ nearly 4,000 workers on subcontracts from every major aircraft manufacturer. Molded plywood fuselages for training aircraft, primarily the AT-6 and BT-13, were built to free aluminum for combat aircraft. Doors, hatches, and gun turrets were built for nearly every warbird. Doak's postwar engineering efforts were directed toward vertical flight, with ducted-fan experiments leading to a contract with the army. The Doak Model 16 flew successfully from Torrance Airport in 1958 and subsequently with the army designation of VZ-4DA. It was eventually transferred to the National Aeronautics and Space Administration and then to the Army Transportation Museum at Fort Eustis, Virginia.

The Acme Aircraft Company, an inspiration of Hugh Crawford and Charles Roger Keeney, was the first business to arrive on the Lomita Flight Strip, nearly three years before the city's acquisition of the field. In October 1945, Roger quietly left Douglas Aircraft to form his own company, moving into the vacant maintenance hangar that had serviced so many P-38s. From this austere beginning, Roger built a unique business by offering innovative services, aircraft designs, and modifications. The services included pumping fuel, adding jet engines to propeller aircraft, retrieving fishing floats from offshore islands, designing and flying private airplanes, teaching flying and aircraft repair, determining the proper weight and balance of flying loads, converting single engine aircraft to twins, and other duties. Acme Aircraft thrives today.

The dozens of businesses on the original Lomita Flight Strip acreage should also be acknowledged. Today the Rolling Hills Shopping Center stands where the barracks originally stood. The stores and automobile dealerships along Crenshaw Boulevard and Pacific Coast Highway are all on airport property. Dozens of on-field businesses, both past and present, thrive here. The largest of these, Robinson Helicopters, is discussed in Chapter 5. Robinson is the world's largest manufacturer of civilian aircraft and a proud tenant on the Torrance Airport since 1973.

Edmond Doak, a vice president of Douglas Aircraft Company, founded the Doak Aircraft Company in 1939. In an age of entrepreneurs and self-made engineers, Doak began his career in 1913 as a stock boy with the Glenn L. Martin Company, the first aircraft company west of the Mississippi. While there, he rubbed elbows with Donald Douglas Sr. and Lawrence Bell and later with Jack Northrop and Dutch Kindleberger. (Courtesy Virginia Doak.)

In 1940, the buildings of the former Torrance Flat Glass Company were vacant and available on Abalone Street, south of downtown Torrance. Doak swept out the broken glass and promptly opened shop. (Courtesy Virginia Doak.)

The Army-Navy "E" Award for Excellence proudly flies above the Doak Aircraft plant in the converted glass-company building. Throughout World War II, subcontracts for aircraft components from nearly every aircraft manufacturer poured in—just as Doak had anticipated when he left Douglas Aircraft in 1938. (Courtesy Virginia Doak.)

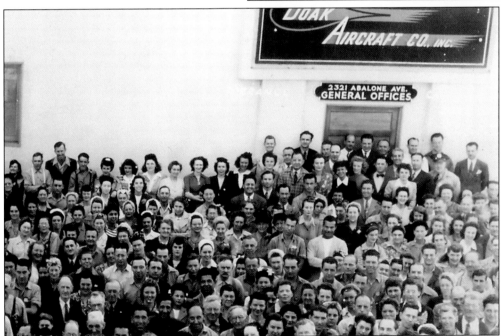

At its wartime peak, Doak employed nearly 4,000 assemblers, technicians, engineers, and administrative staff. A portion of the hardworking day shift grins for the camera. (Courtesy Virginia Doak.)

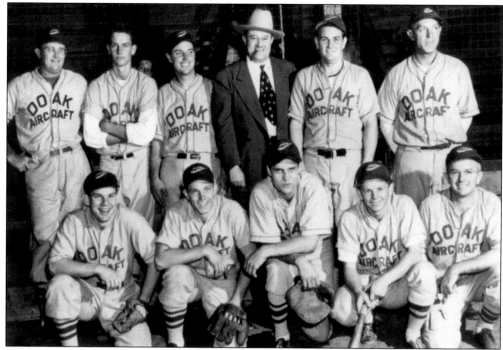

Community-spirited, Doak's company fielded a softball team and proudly participated in local and industrial leagues. (Courtesy Virginia Doak.)

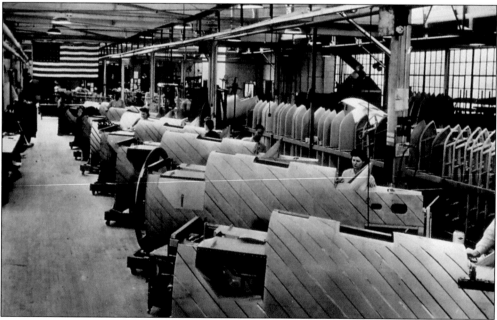

The primary products during the war years were these fuselage assemblies for pilot-training aircraft, notably the North American AT-6 "Texan" and the Vultee BT-13 "Valiant." Molded plywood was used to free aluminum for combat aircraft. The Doak assembly team, mostly women since the men were off at war, constructed aluminum doors, hatches, and gun turrets for nearly every aircraft. (Courtesy Virginia Doak.)

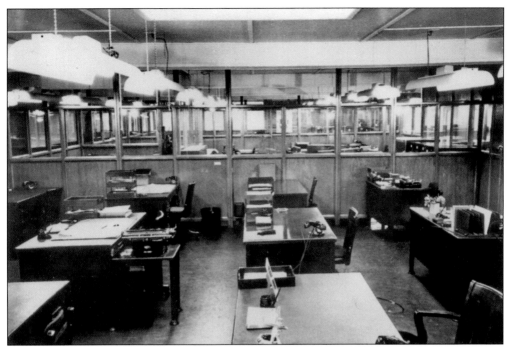

Administrative areas with wooden desks, typewriters, and florescent lighting handled employment, payroll, community relations, company orders and records, contracts, and were also used for schmoozing visiting military dignitaries. (Courtesy Virginia Doak.)

The company cafeteria and break room included a jukebox fully stocked with the popular tunes of Benny Goodman and Glenn Miller. After the war, the company manufactured aluminum lawn furniture for the Kroehler Furniture Company while exploring ideas for vertical flight. Helicopters, ducted fans, counter-rotating impellers, and rigid blades with trailing edge flaps and spoilers were all projects conceived in the visionary mind of Edmond Doak. (Courtesy Virginia Doak.)

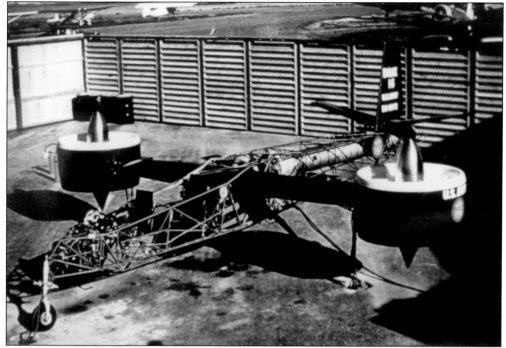

Toward the mid-1950s, army research and development awarded Doak a contract to explore vertical flight coupled with forward flight. In competition with Bell Aircraft, Doak chose to develop a ducted wingtip fan and constructed this first prototype, the Doak Model 16, at Zamperini Field. (Courtesy Virginia Doak.)

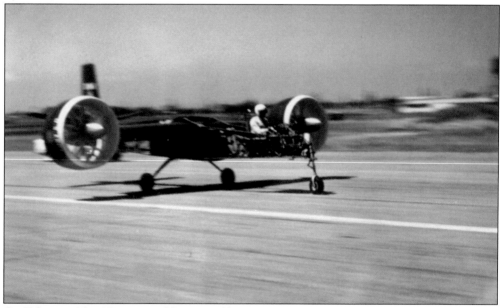

On February 25, 1958, powered by an 825-horsepower Lycoming gas turbine engine and with Jim Reichert at the controls, the Doak Model 16 made history by successfully lifting off at Torrance Municipal Airport and smoothly converting from vertical to horizontal flight. (Courtesy Virginia Doak.)

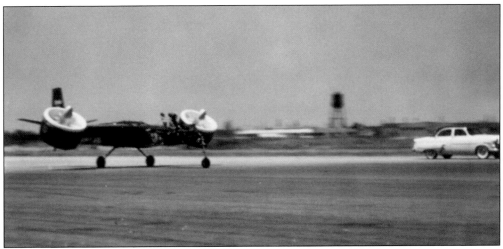

Driven by an aluminum shaft from a T-coupler off the turbine and followed by a pace car, the ducted-fan rotors tilted perfectly to the vertical and the Doak Model 16 rose smoothly into the air. The army accepted the Model 16 and dubbed it the Army Tiltrotor Model VZ-4DA. Tests continued for more than a year at Edwards Air Force Base in Southern California's Antelope Valley and at several bases in the Midwest. (Courtesy Virginia Doak.)

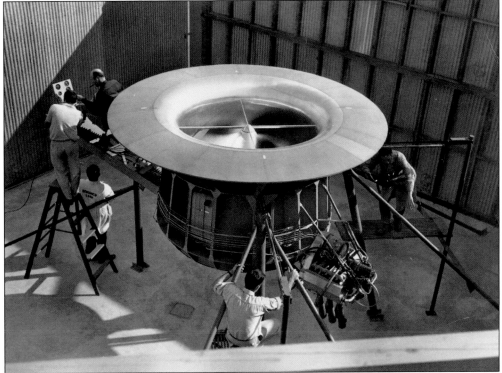

In 1961, when Congress transferred all airplane work to the air force, Doak was forced to close his doors. His company had never been an air-force prime contractor. His plant at 223rd Street and Western Avenue in Torrance was sold. He opened an experimental shop with a few of his top engineers a few blocks away at 1617 Border Avenue. These visionary craftsmen experimented with nearly 30 futuristic models of vertical-lift airframes.

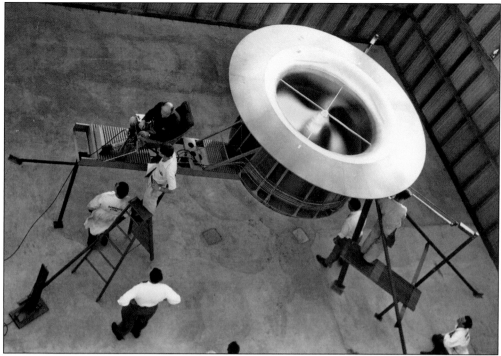

A counter-rotating impeller was installed in a duct driven by an automobile engine on a test stand to evaluate vertical-thrust concepts. (Courtesy Virginia Doak.)

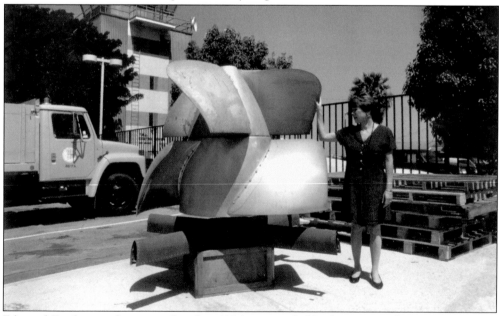

Edmond Doak passed away in October 1986 surrounded by his unique designs. He left his wife, Virginia, with a wealth of aviation artifacts for posterity to discover and appreciate. His ducted-fan impeller was donated to Zamperini Field in 1997 and is examined here by Diana Matovich of the airport staff. It was refinished and mounted on the flight line side of the General Aviation Center.

The logo of the Acme Aircraft Company, founded in October 1945, was created by Charles Roger Keeney while the field was still the Lomita Flight Strip. The City of Torrance did not obtain a permit to use the runway until December 7, 1946. Acme Aircraft remains in business today, by far the longest-running business on the field. (Courtesy Roger Keeney.)

Born in February 1911 in Cucamonga, California, Roger Keeney received an Aircraft and Engine rating in 1930 working for Timm Aircraft. That was followed by a pilot's license in 1931. His career with Douglas Aircraft began in 1934 in Santa Monica before moving to Long Beach. He drove past the Lomita Flight Strip all through the war, noting the warbird activity that led to the inspiration for Acme Aircraft Company. (Courtesy Roger Keeney.)

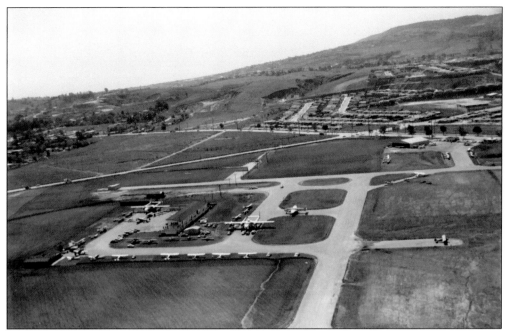

Acme Aircraft was located at the east end of Lomita Flight Strip in the Army Air Corps P-38 maintenance hangar. The view to the east and south in the late 1940s shows very lightly developed land. (Courtesy Roger Keeney.)

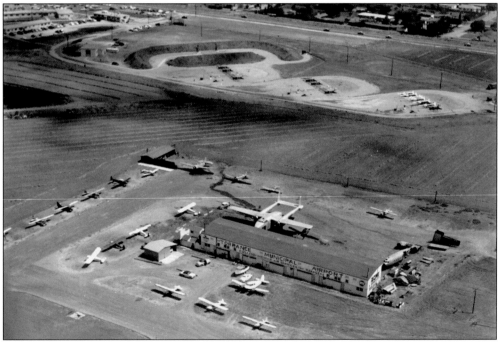

With the field unfenced, Acme had many drop-in visitors wondering what they were doing and inquiring about airplane rides. Interest in flying and in the airport grew rapidly. Note the cold-war Nike missile installation constructed in 1956 at the top of the photograph. It was deactivated in 1963. (Courtesy Roger Keeney.)

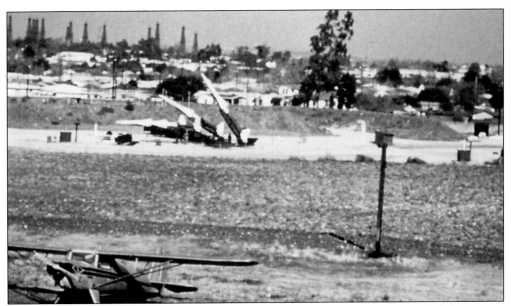

From 1956 through 1963, Nike Station LA-57 and 15 similar stations surrounded the greater Los Angeles area. The Torrance site housed conventional warhead Nike Ajax missiles in three underground bunkers, each with four launchers. These surface-to-air missiles were the final measure in combating invading hostile aircraft that may have penetrated radar detection and F-101 interceptors based at Oxnard, California. By 1963, station LA-57 was decommissioned. (Courtesy Roger Keeney.)

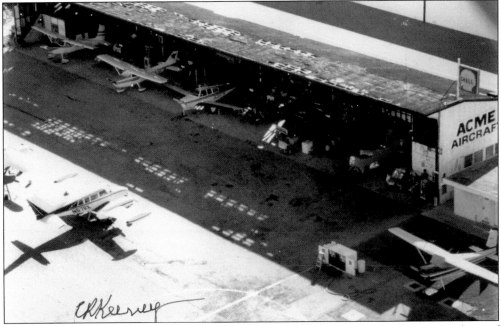

The old 34- by 192-foot P-38 maintenance hangar was beginning to show its age as the roof began deteriorating (see page 102). With prevailing winds blowing off the Pacific Ocean from the west, the entire east side remained open with only heavy-draw curtains for weather protection. (Courtesy Roger Keeney.)

One of Acme's primary businesses was weight and balance, as with this Cessna 170 in 1966. Aircraft maintenance records must reflect periodic checks of the unloaded weight and exact center of gravity. Acme was an FAA-licensed facility for determining these figures on everything from light private planes to airliners. (Courtesy Roger Keeney.)

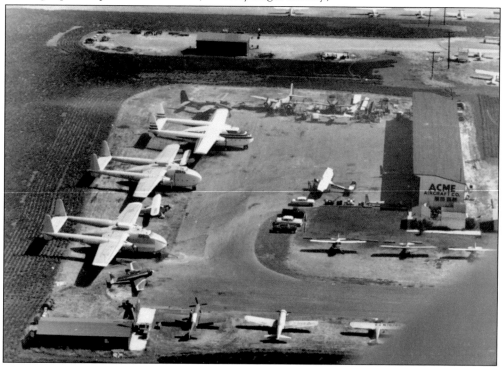

The Acme flight line in 1956 included Fairchild C-82s, Grumman F7F and F8F warbirds, and a Convair L-13A. (Courtesy Roger Keeney.)

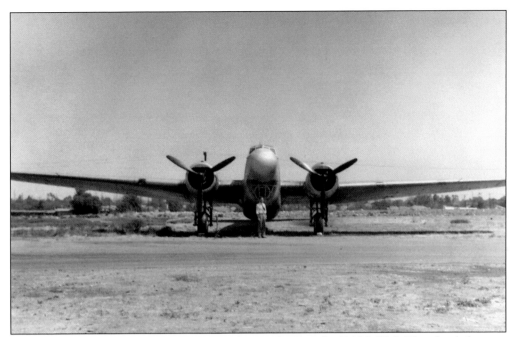

One of Acme's initial projects in 1945 was this surplus Douglas B-18A "Bolo" bomber belonging to Sonora Air Freight, one of two B-18s transporting fish and other seafood from Mexico to restaurants in the United States. (Courtesy Roger Keeney.)

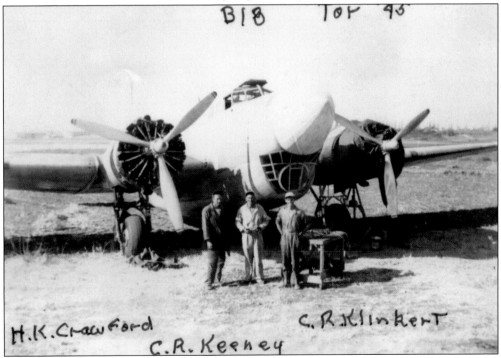

Pictured here in 1945, from left to right, are Hugh Crawford, Roger Keeney, and Charlie Klinkert after modifying the B-18A of Sonora Air Freight for importing seafood from Mexico. (Courtesy Roger Keeney.)

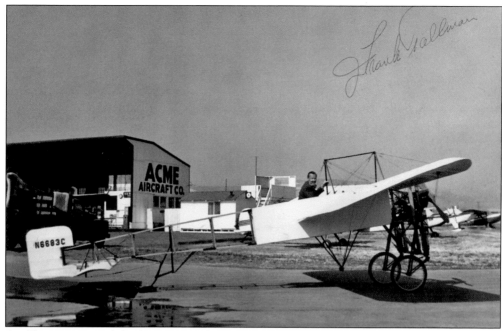

A seldom-seen aircraft for the time was this 1912 Bleriot that was owned by movie stunt-pilot Frank Tallman. Frank lived in Palos Verdes and worked in Orange County, so he occasionally took the opportunity to fly home to Torrance in one of his fleet of vintage aircraft. The Bleriot was the first aircraft to fly across the English Channel on July 25, 1909. (Courtesy Roger Keeney.)

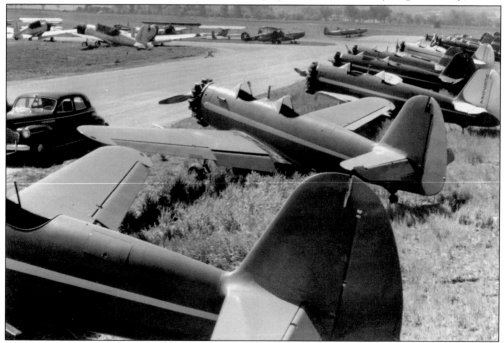

Another fleet of Acme aircraft was this grouping of naval training aircraft, the N2T-1 "Tutor," manufactured by Timm Aircraft Company, Van Nuys Metropolitan Airport. Otto Timm was an early employer of Roger Keeney. (Courtesy Roger Keeney.)

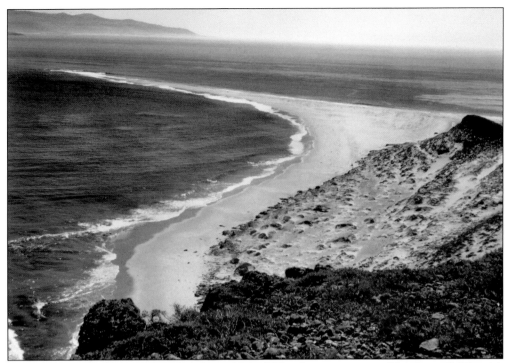

The beautiful beaches of uninhabited San Miguel Island, westernmost of Southern California's Channel Islands, proved to be a great temptation for Roger Keeney and his Cessna 180 in March 1969. (Courtesy Roger Keeney.)

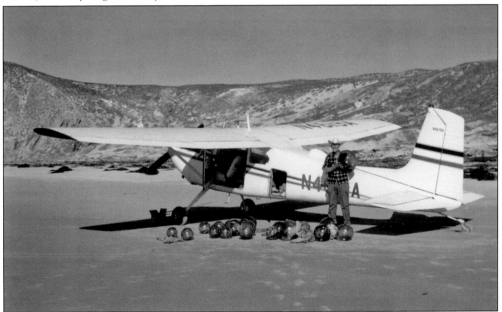

San Miguel proved to be a treasure trove of Pacific flotsam, particularly fishing floats that had broken loose from their nets and drifted across the Pacific Ocean from Japanese fishermen. Roger is clearly pleased with this trophy collection of floats, which are highly prized by collectors and interior decorators. (Courtesy Roger Keeney.)

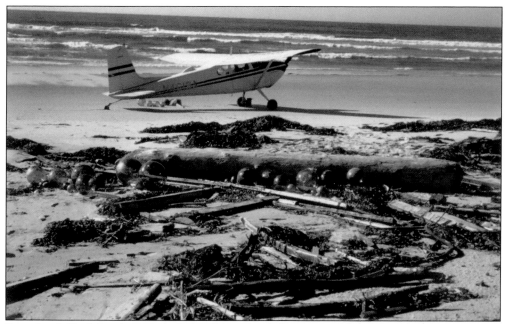

Roger has dubbed this photograph the best he ever took, because it includes examples of a wide variety of material found washed up on the beaches of San Miguel Island. (Courtesy Roger Keeney.)

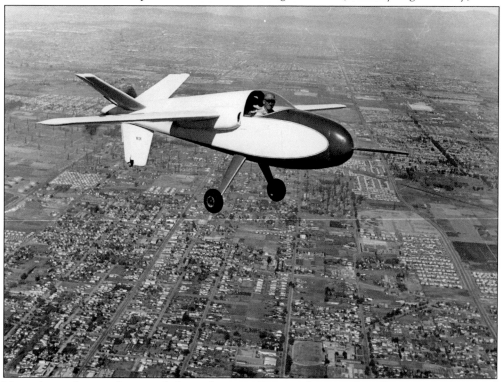

Not to be outdone in the aircraft-design business, Roger is the test pilot of his own experimental aircraft, the *Sierra Sue*. Note the unique pusher propeller as he cruises over the future site of the mammoth Del Amo Fashion Center in Torrance. (Courtesy Roger Keeney.)

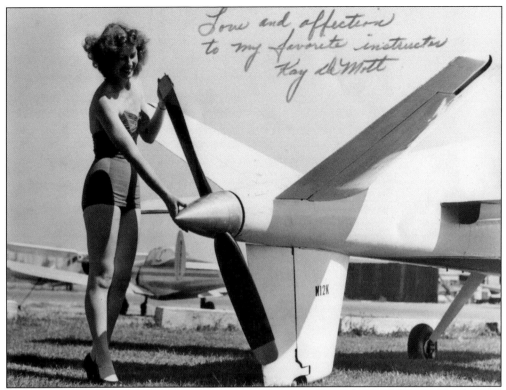

Love and affection to my favorite instructor
Kay DeMott

Kay DeMott, one of Roger's student pilots, is checking out *Sierra Sue*, perhaps contemplating a check flight of her own. (Courtesy Roger Keeney.)

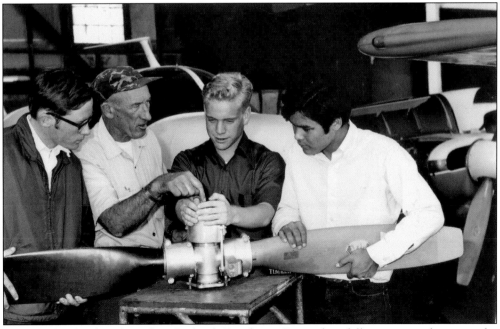

Three high-school students from Redondo Beach give Roger their full attention as he covers the complexities of a variable pitch propeller. (Courtesy Roger Keeney.)

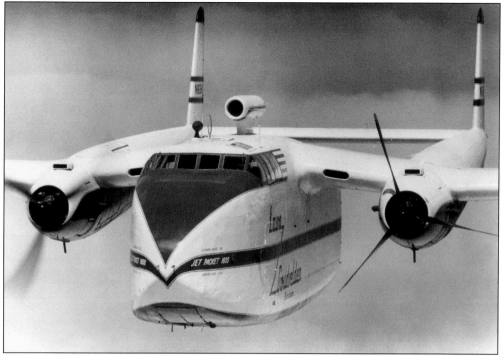

The mainstay of Acme Aircraft from 1954 to 1964 was the addition of a Westinghouse model J-30 gas turbine engine above the cabin of the popular Fairchild C-82 "Packet" transport. With pilot Bat Masterson at the controls, Roger is demonstrating controllable engine-out procedures with turbojet assistance. (Courtesy Roger Keeney.)

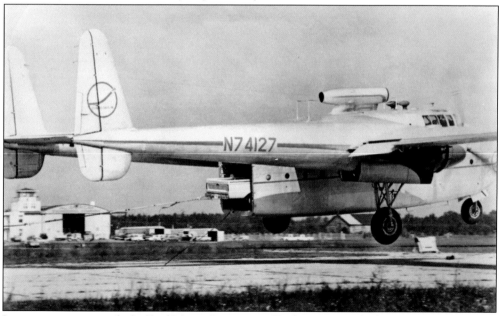

In an arrangement with the Ford Motor Company, a Ford promotional advertisement was filmed using an Acme-modified C-82 and a new Ford pickup truck. In this first frame, the pickup truck is being extracted from the turbo-assisted C-82 while in flight. (Courtesy Roger Keeney.)

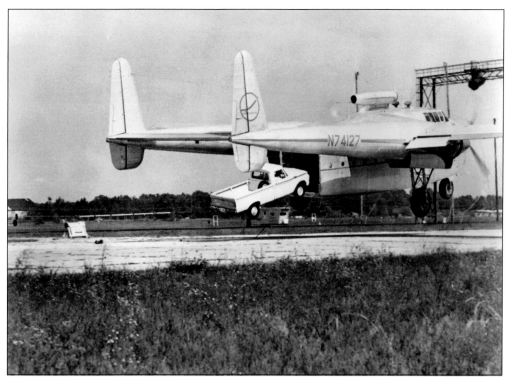

The pickup begins its descent to the runway. (Courtesy Roger Keeney.)

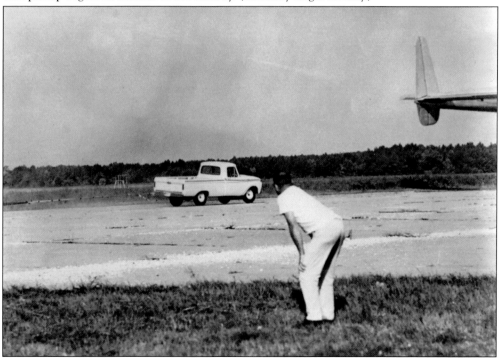

In this final frame, a driver walks to the truck, starts it, and drives away, a demonstration of the rugged reliability of Ford pickup trucks. (Courtesy Roger Keeney.)

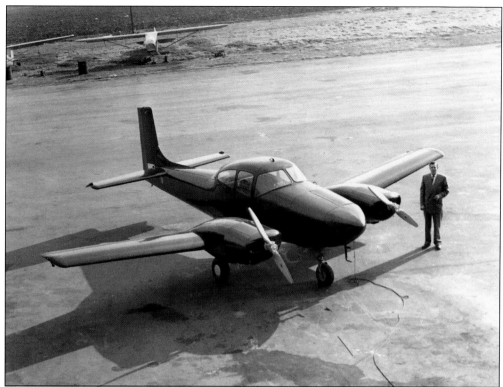

Another of Acme's more unique projects was the design and modification of the popular postwar North American/Ryan "Navion." Originally manufactured as a single-engine aircraft for the general aviation market, "Navion" was redesigned by Acme as a light twin. Fred Anderson, one of the design team, stands alongside the finished product. (Courtesy Roger Keeney.)

Conversion completed, the modified twin "Navion" is resplendent in its new paint and ready for a test flight. (Courtesy Roger Keeney.)

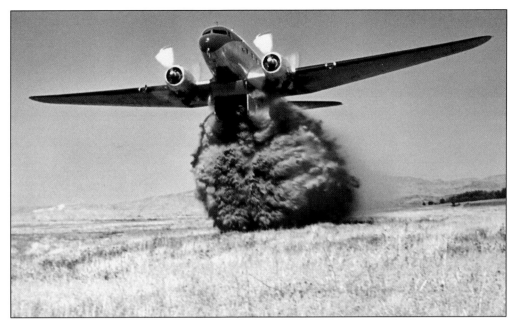

Mel Chrisler, a rancher from Wyoming, brought his Douglas DC-3 to Acme for design, installation, and FAA certification of a belly tank to hold fire retardant. Acme installed a 1,000-gallon tank with four 250-gallon sections that could be emptied in any combination. The tanks proved perfect during this test flight, and Chrisler returned to Wyoming very pleased with the finished product. (Courtesy Roger Keeney.)

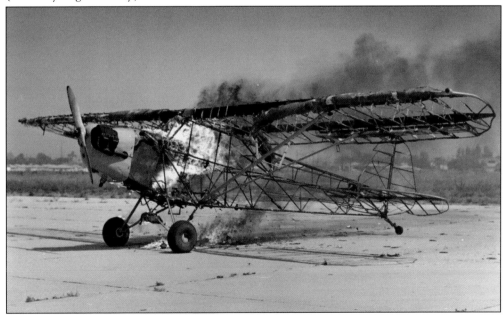

This is a prime example of why the FAA frowns on do-it-yourself maintenance. Two young men, after working on the fuel line of this J-3 Piper Cub, taxied to the runway for a test flight. When flames erupted, they both jumped out uninjured, but the gas tank fed the flames until every inch of fabric and framework had been consumed. The aircraft was a total loss. (Courtesy Roger Keeney.)

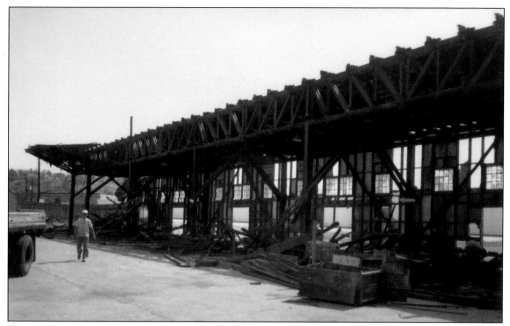

The venerable maintenance hangar, built in 1942 by the Army Corps of Engineers, served the Army Air Corps, the City of Torrance, and tenant Acme Aircraft faithfully for over 40 years but was falling into serious disrepair. (Courtesy Roger Keeney.)

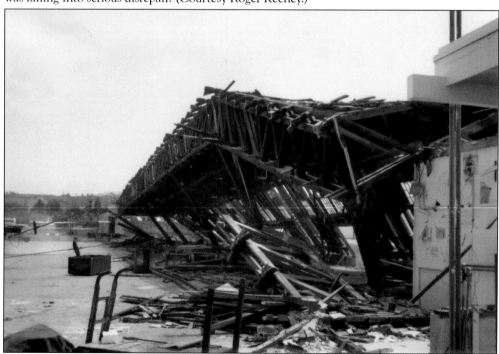

In 1982, Torrance building inspectors judged the structure to be no longer serviceable and ordered it demolished. Acme Aircraft hired a crew from Mexico to pull it down, completing the job in a single day. Most of the structural timbers were removed, cleaned up, and trucked to Mexico when the crew returned home. (Courtesy Roger Keeney.)

Five

ROBINSON HELICOPTERS

Frank Robinson, the youngest of four, was born in Washington in 1930. Captivated with helicopters from a very early age, he earned a B.S. degree in mechanical engineering in 1957 at the University of Washington. His career moved through helicopter work at Cessna Aircraft, McCulloch Motors, Kaman Aircraft, and Bell Helicopters. In 1969, he transferred to Hughes Helicopters in Culver City, California. In 1973, unable to sell the idea of a light, inexpensive general aviation helicopter to his employers, he started his own company, working out of his living room in Palos Verdes, California, bonding tail rotor blades in his kitchen oven.

The first prototype R-22 flew in 1975, followed by over three years of testing and technical analysis towards certification. The first prototype was lost in the ocean off Palos Verdes when a casting failed on the tail rotor boom. Undaunted a second prototype was constructed, finally gaining FAA-type certification in March 1979. The first production R-22 was delivered the following October. The R-22 went on to become the largest-selling civilian helicopter in the world, holding every speed, altitude, and distance record in its class. R-22 No. 1,000 was delivered in March 1989 to the Robinson dealer in England. Custom features included news-copter, law enforcement, marine, and IFR training models with a selection of 80 paint colors in 70 combinations. When stored, the unique two-bladed main rotor allows for parking in a seven-foot space.

Design of the four-place R-44 began in the mid-1980s, completing its first test flight in March 1990 with Frank Robinson at the controls. Three more years of testing paid off with FAA certification awarded in December 1992. Currently 1,200 employees are producing 15 R-44s and two R-22s five days a week, more than all other North American manufacturers combined.

Since 1987, 3,700 R-22s and 2,400 R-44s have been delivered in 50 countries, with a variety of support services such as flight instructor training, safety, and maintenance courses for maintenance technicians plus a factory overhaul program for older models. The worldwide organization includes 110 dealers and 290 service centers. Today Robinson Helicopters continues as a true family corporation with Frank, his son Kurt, and daughter Teri all in key management roles.

Frank Robinson's impish grin belies the indomitable spirit of a self-made man, a successful entrepreneur, and a person who knew he had a great idea and stuck with it. Would that all of us in our mid-70s could sport the grin and twinkle of a Frank Robinson. (Courtesy Robinson Helicopters.)

It is hard to believe the Robinson Helicopters of today had such humble beginnings in this well-worn corrugated steel building at the Torrance Municipal Airport during the early 1970s. In 1994, this building disappeared beneath the first of several manufacturing expansions. (Courtesy Robinson Helicopters.)

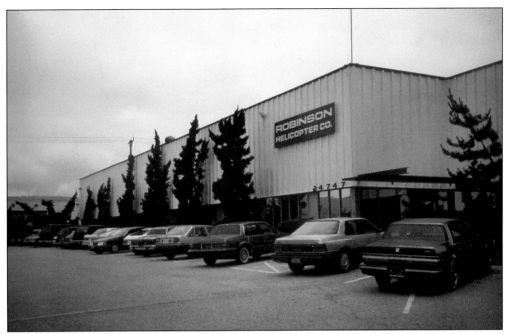

The first full-fledged manufacturing operation was in this building at 24747 Crenshaw Boulevard in Torrance, just north of the Torrance Airport. (Courtesy Robinson Helicopters.)

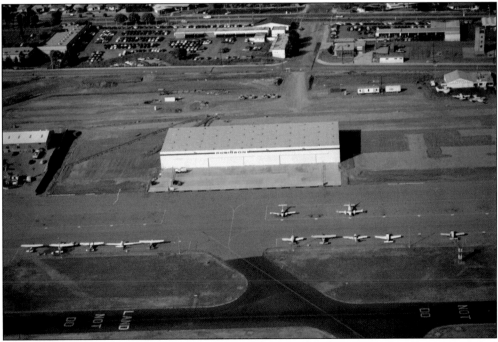

As the success of the two-place R-22 spread worldwide and orders began pouring in, Frank laid out a manufacturing facility to his own specifications. With the assistance of Torrance mayor Katy Geissert, ground was broken for a plant at the east end of the Torrance Airport. (Courtesy Robinson Helicopters.)

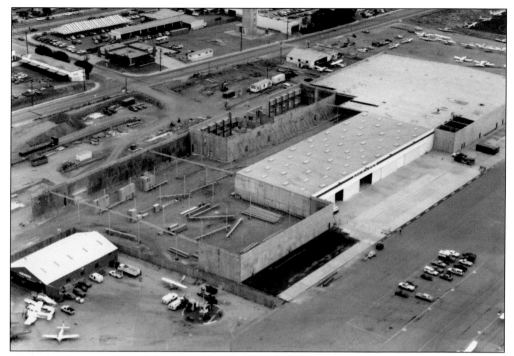

With the development of the four-place R-44 in 1990, even more manufacturing space and administrative offices were needed. Construction began to bring total manufacturing capacity to 260,000 square feet. (Courtesy Robinson Helicopters.)

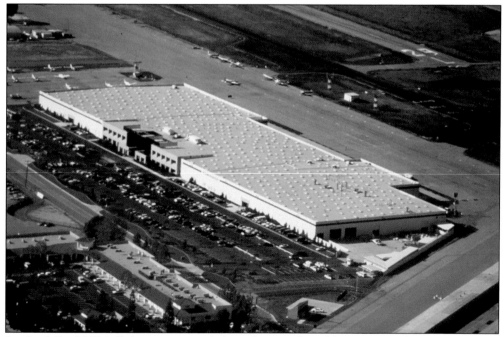

In the fall of 2004, Robinson expanded to the west by adding a second 220,000-square-foot manufacturing building, bringing the total to 480,000 square feet. (Courtesy Robinson Helicopters.)

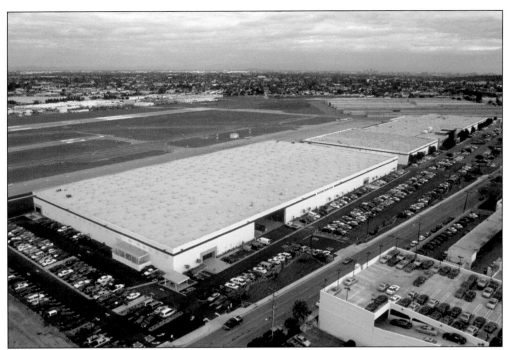

The completed facility on Airport Drive grew to 1,200 employees producing 17 aircraft per week, more than three per day. Every aircraft is test flown at least twice by a four-man team of test pilots to ensure all bugs have been worked out before customer delivery. (Courtesy Robinson Helicopters.)

The R-22 holds every world record in its class, including speed, altitude, and distance. Fitted with a Lycoming 180-horsepower, four-cylinder engine, the No. 1,000 R-22 was delivered to the Robinson dealer in England in 1989. (Courtesy Robinson Helicopters.)

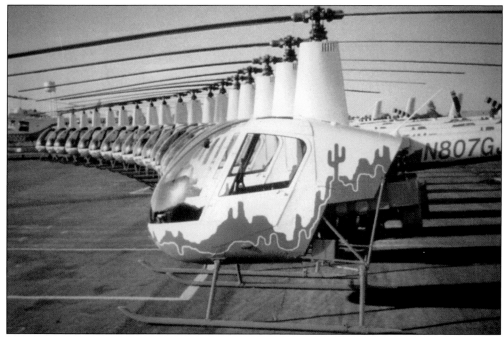

A Robinson customer in Arizona proudly displayed his multicolored flight line of R-22s. The factory can customize finishes from a choice of 80 colors in 70 combinations. Note how the two-bladed main rotor can be aligned for ease of side-by-side parking. (Courtesy Robinson Helicopters.)

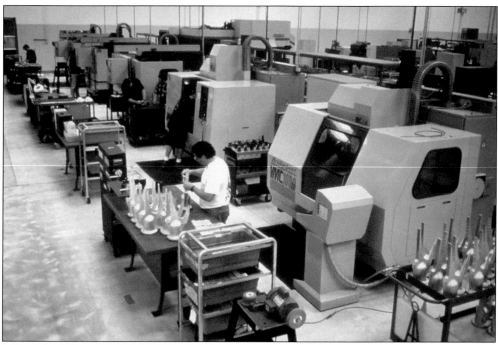

Top-of-the-line, state-of-the-art, numerically controlled machining ensures the ability to hold close tolerances while keeping manufacturing costs low. (Courtesy Robinson Helicopters.)

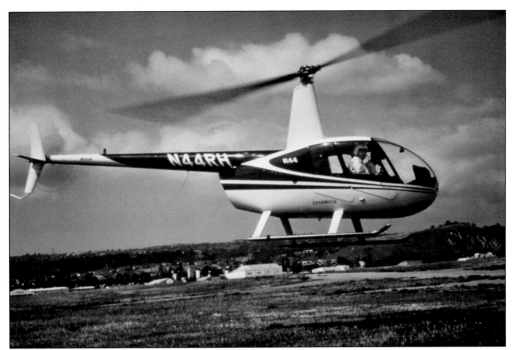

Based on the R-22's success, Frank Robinson initiated development of a four-place version, the R-44, in the mid-1980s. The first R-44 was test flown in March 1990 with Robinson at the controls. It obtained FAA-type acceptance in December 1992, fitted with a Lycoming 260-horsepower, six-cylinder engine. (Courtesy Robinson Helicopters.)

Frank has adhered to the principle of keeping everything very simple, typified by this no frills, uncluttered instrument panel. (Courtesy Robinson Helicopters.)

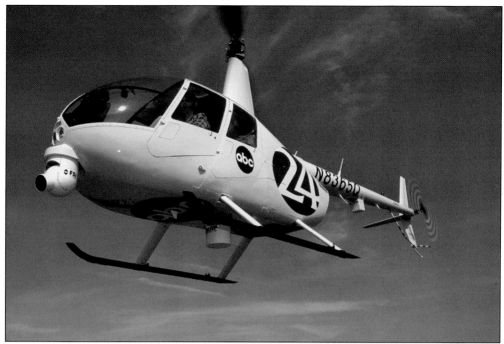

The R-44 can be configured to meet special customer requirements such as this ENG, or Electronic News Gathering, variant with a stabilized television camera in the nose pod. (Courtesy Robinson Helicopters.)

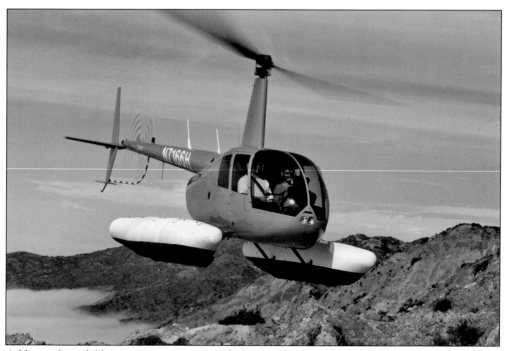

Additional available custom equipment includes this R-44 Raven II Clipper with fixed floats for operation in a marine environment. (Courtesy Robinson Helicopters.)

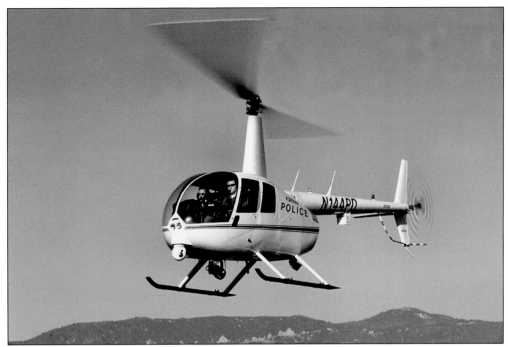

Police variations are also available with cameras, police radios, a forward-looking infrared sensor (FLIR), Lo-Jack tracking, a high-intensity searchlight, and a moving map display similar to ground police vehicles. (Courtesy Robinson Helicopters.)

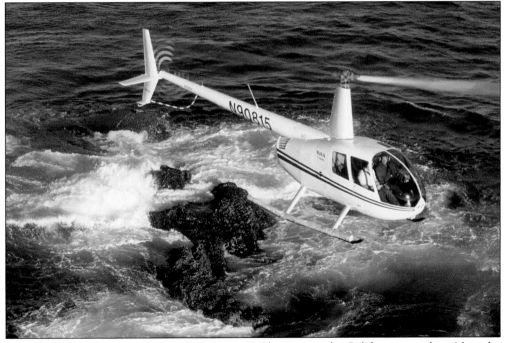

A test pilot is building time on an R-44 Raven II Clipper over the California coastline. Note the pop-out safety floats that the pilot can inflate in three seconds during over-water flights. They will remain inflated for up to three hours. (Courtesy Robinson Helicopters.)

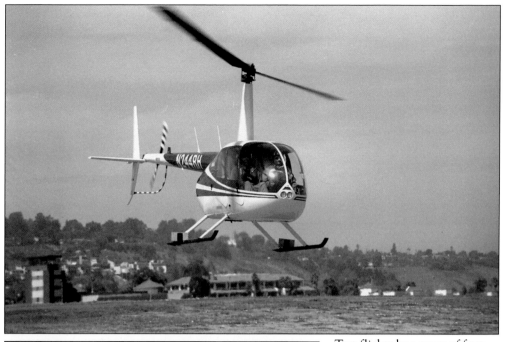

Test flights by a team of four test pilots are conducted in two stages. The initial flight after assembly is to verify hover, track, and balance performance. The second is a mini cross-country flight to build at least four hours of flight time before delivery. (Courtesy Robinson Helicopters.)

The critical static rotor-balancing tests conducted before installation ensure strength, minimal vibration, and proper flight performance. (Courtesy David Harmon.)

The six-cylinder, 260-horsepower Lycoming O-540 engine powers the hydraulically controlled R-44 to a comfortable 130 miles per hour cruise. Thorough receiving inspections are conducted before installation in the R-44 line. Production of the R-44 has reached 2,400 and is still increasing. (Courtesy David Harmon.)

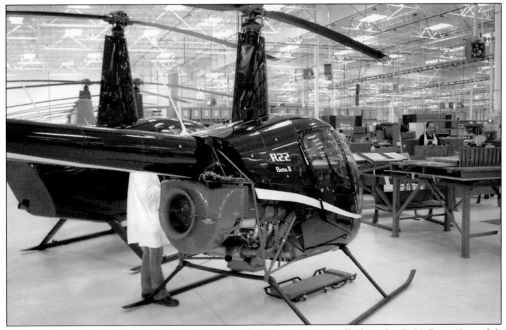

This is the venerable four-cylinder Lycoming O-360 engine installed in the R-22 Beta II model. This Lycoming workhorse has been derated to 131 horsepower for takeoff and 124 for cruise at a comfortable 110 miles per hour. Over 3,700 R-22s have been delivered worldwide. (Courtesy David Harmon.)

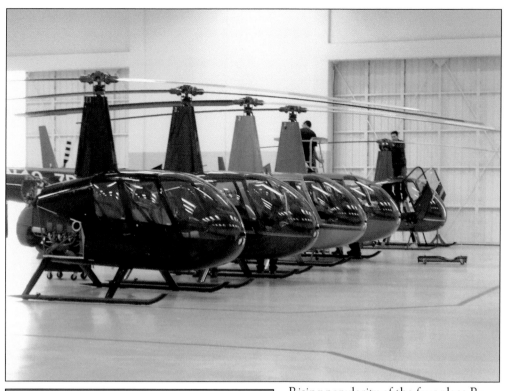

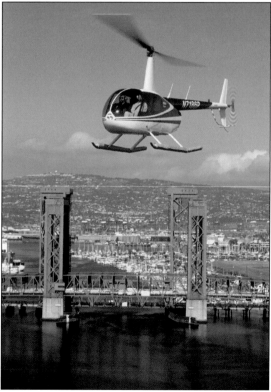

Rising popularity of the four-place R-44 Raven has boosted production to just over three per day, with a total of 2,400 delivered to date through 110 dealerships in 50 nations. (Courtesy David Harmon.)

An R-44 with pop-out safety floats is in a test flight over Terminal Island and the Los Angeles and Long Beach Harbors. The view looks west with the Palos Verdes Peninsula in the background and the 1946-vintage Commodore Heim lift bridge in the foreground—one of three bridges connecting Terminal Island with the mainland. (Courtesy Robinson Helicopters.)

Six

LOUIS S. ZAMPERINI

From a trouble-prone adolescent to a world-class prep and college distance runner and Olympic athlete, to World War II-era bombardier, prisoner-of-war survivor, author, and religious educator, "Torrance Tornado" Lou Zamperini has done it all. This chapter will attempt to convey why the airport carries his name, perhaps the only airport named for a one-time juvenile delinquent.

In an attempt to resolve his delinquency, Lou was pushed onto the high-school track team by his older brother Pete, who would run alongside him with a switch. It worked. As a junior in 1934, Lou set a world prep record in the one-mile run (without Pete's switch), ran the 5,000 meters in the 1936 Berlin Olympics, then later set a national collegiate mile mark at the University of Southern California.

As war clouds gathered, Lou enlisted in the Army Air Corps, trained as a bombardier, and deployed to Hawaii with the 307th Bombardment Group, 7th Air Force. In May 1943, his borrowed B-24 crashed into the sea, and Lou, the pilot, and the tail gunner were the only survivors.

The next 47 days on a rubber raft was an odyssey of little food, rainwater, sharks, albatrosses, a strafing attack, prayer, precarious life, and imminent death. The tail gunner perished on the 33rd day, and two weeks later, the raft drifted onto Japanese-held Kwajalein in the Marshall Islands. For the next two and a half years, Lou was shifted between prison camps and starved and beaten by a sadistic sergeant known as "The Bird." At war's end, a reporter for the *New York Times* interviewed Lou and wired home his incredible story, the first time the world knew Lou was still alive.

He returned to Long Beach, was reunited with his family, and was greeted with a tumultuous reception in Torrance. Both the high-school athletic field and the airport were named after him. But as the brouhaha faded, Lou was unable to shake nightmares of "The Bird." Disaffected and rootless, he was dragged by his friends to hear evangelist Billy Graham. Lou recalled the thousands of promises he made on the raft and in the camps and began his personal conversion, returning twice to Japan to forgive his guards, even "The Bird."

Today Lou resides in Hollywood, running a sports program for at-risk youth. It seems the incredible story of Louis S. Zamperini has only just begun.

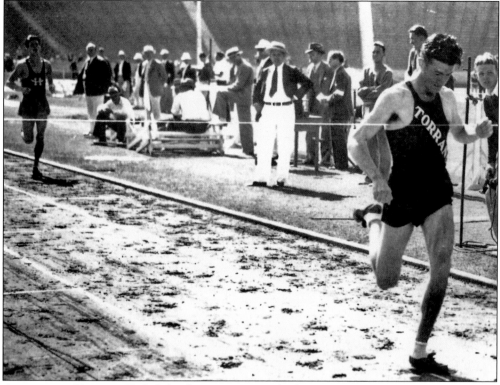

As a junior at Torrance High School, Lou Zamperini broke an 18-year international prep record by running a mile in four minutes and 21.3 seconds. Gaylord Mercer of Glendale's Hoover High (left) trailed by 10 yards and fell exhausted at the finish. All other competitors had dropped out from the blistering pace. Lou's record stood for more than 20 years and gained him personal recognition that turned him away from his trouble-prone youth. (Courtesy Louis Zamperini.)

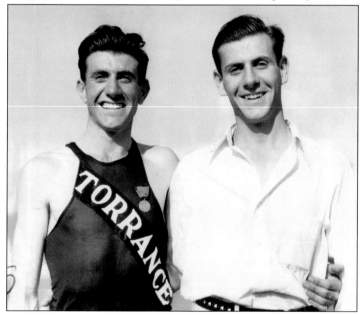

Lou and his brother Pete, older by two years, celebrate Lou's record-setting mile run in the Los Angeles Memorial Coliseum in 1934. Lou claims he was able to chat easily with interviewers in less than a minute after the finish. (Courtesy Louis Zamperini.)

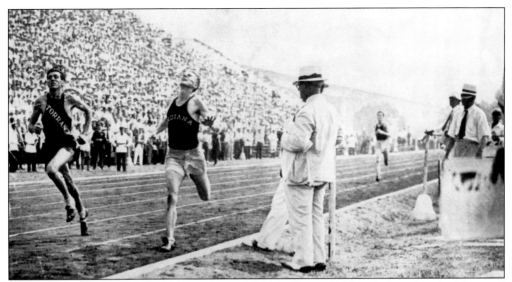

In July 1936, the Olympic qualifying track-and-field trials were held in the Los Angeles Memorial Coliseum. Just one year out of high school, Lou finished in a dead heat in the 5,000 meters with veteran Don Lash. Note Lou is still wearing his Torrance High School jersey made for him by his mother, Louise. (Courtesy Louis Zamperini.)

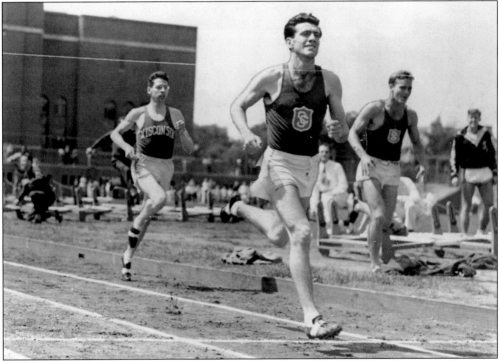

In June 1938, at the NCAA national track meet held at the Memorial Stadium of the University of Minnesota, Lou competed for the University of Southern California. Fresh from his Olympic performance in Berlin in 1936, he again bested the field with a record of four minutes and 8.3 seconds in the mile run. Chuck Fenske of the University of Wisconsin was second. USC won the meet. (Courtesy Louis Zamperini.)

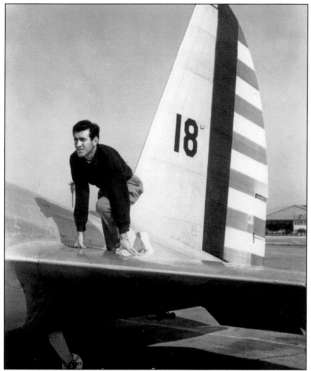

Zamperini is pictured after enlisting in the Army Air Corps at Fort McArthur, California, on September 28, 1941. Aviation cadet Zamperini began training in January 1942 at Ellington Field, Texas. He completed bombardier training and was commissioned a 2nd lieutenant on August 13, 1942. Five days later, he joined the 307th Bombardment Group, 7th Air Force, and was deployed to Hawaii on October 26, 1942. (Courtesy Louis Zamperini.)

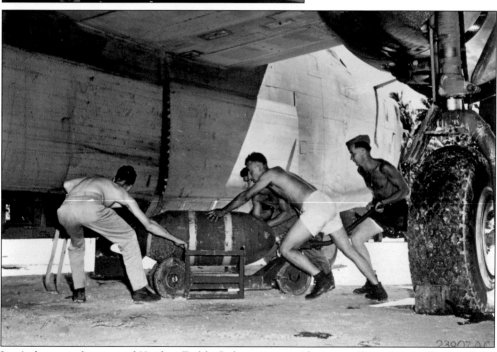

Lou's first combat out of Kualoa Field, Oahu, was on Christmas Eve 1942 as B-24s of the 307th plastered Japanese-held Wake Island with 500- and 1,000-pound bombs. Six subsequent missions bombed Japanese installations on Nauru, Makin, and Tarawa Islands. (Courtesy Louis Zamperini.)

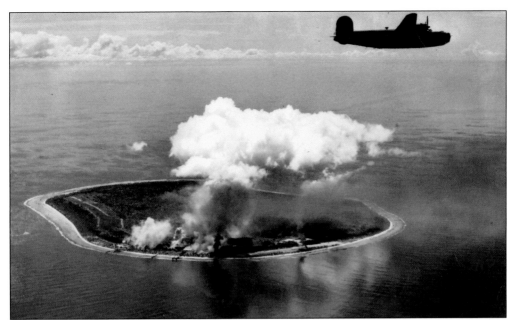

On April 19, 1943, Lou and his B-24 "Superman" bombed the phosphate plants and airfield on tiny Japanese-held Nauru Island but not without considerable resistance. Five hundred bullet and cannon shells punctured "Superman"—the right tail was shot off, hydraulics shot out, one tire flattened, one crewman killed, and several others wounded. Somehow the flight staggered back to Funafuti Island with no aircraft losses. (Courtesy Louis Zamperini.)

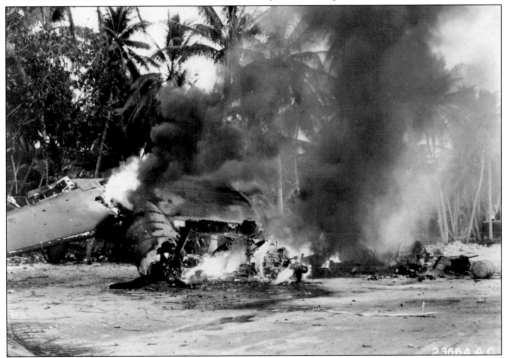

The following day, the Japanese retaliated with a spectacular raid on Funafuti Island that cost the Americans two B-24s, a C-47, and a few casualties. (Courtesy Louis Zamperini.)

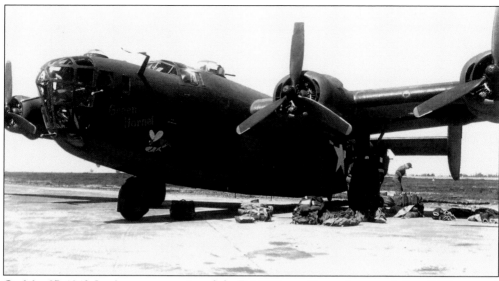

On May 27, 1943, Lou's crew was assigned the B-24 "Green Hornet" to search for a B-25 reported down near Palmyra Island. At 2:00 p.m., two engines failed, and the B-24 hit the water and exploded. Only Lou, pilot Russell Phillips, and tail gunner Francis McNamara survived. Thirty-three days later, McNamara perished and was buried at sea. On July 13, their raft drifted to the Japanese-held Marshall Islands. Lou's normal 165 pounds had dwindled to 67 pounds. (Courtesy Louis Zamperini.)

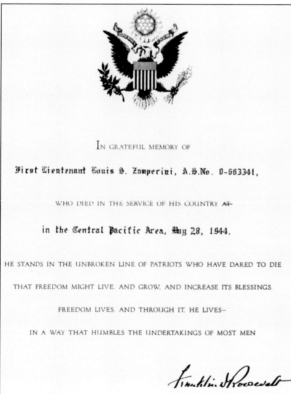

IN GRATEFUL MEMORY OF

First Lieutenant Louis S. Zamperini, A.S.No. 0-663341,

WHO DIED IN THE SERVICE OF HIS COUNTRY AT

in the Central Pacific Area, Aug 28, 1944.

HE STANDS IN THE UNBROKEN LINE OF PATRIOTS WHO HAVE DARED TO DIE

THAT FREEDOM MIGHT LIVE, AND GROW, AND INCREASE ITS BLESSINGS.

FREEDOM LIVES, AND THROUGH IT, HE LIVES—

IN A WAY THAT HUMBLES THE UNDERTAKINGS OF MOST MEN

Franklin D. Roosevelt

PRESIDENT OF THE UNITED STATES OF AMERICA

When over a year had passed with no knowledge of Lou's fate, the War Department presumed him dead and sent this standard condolence letter from Pres. Franklin Roosevelt to Lou's parents in Torrance. Lou's mother, Louise, would have none of it, however, and just knew her son was still alive somewhere. (Courtesy Louis Zamperini.)

Lou spent the next two and a half years in a series of prison camps beginning with 42 days on Kwajalein, where he narrowly escaped a beheading. A secret prisoner interrogation camp at Ofuna in the hills surrounding the city of Yokohama followed. Lou's cell was the third window from the right. In the spring of 1944, Marine Maj. Gregory "Pappy" Boyington, of "Black Sheep Squadron" fame, joined Lou in the adjacent cell. (Courtesy Louis Zamperini.)

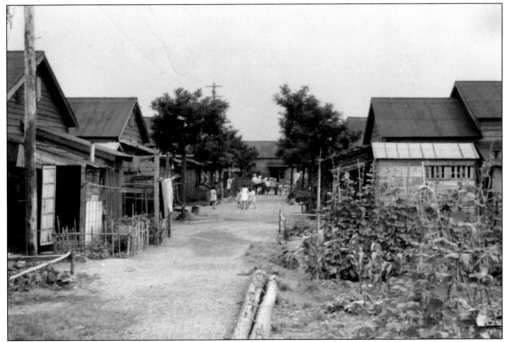

Lou was transferred to Omori prison near Tokyo on September 10, 1944, where he continued to be severely starved, mistreated, and beaten by the sadistic, officer-hating Sgt. Matsuhiro Watanabe, nicknamed "The Bird." (Courtesy Louis Zamperini.)

On March 1, 1945, Lou was again transferred, along with The Bird, to Camp 4-B at Naoetsu, Japan, near Nagano, the site of the 1998 Olympic Winter Games. Treatment under The Bird and his henchman, Corporal Kono, continued with their inhumane punishment, overworking Zamperini and giving him little food. Never lacking in self-esteem, Lou felt his respect and dignity beginning to slip away. By mid-1945, low-flying B-29s were seen more frequently. On August 31, The Bird disappeared. (Courtesy Louis Zamperini.)

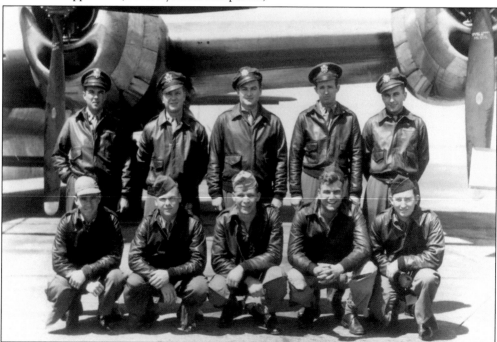

The war with Japan officially ended September 2, 1945, with a steady stream of B-29s thereafter dropping food packages. During a pass at 500 feet, a B-29 banked and Lou made eye contact with the pilot, Byron W. Kinney (second from left, kneeling). Forty years later on November 1, 1985, Lou finally was able to meet Byron in a tearful reunion. (Courtesy Louis Zamperini.)

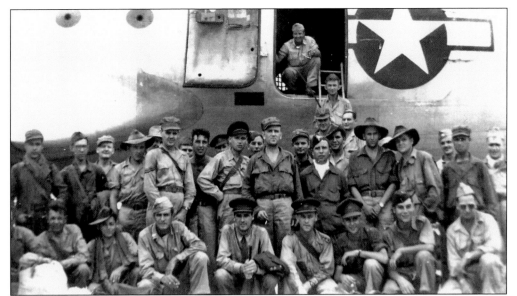

On September 5, 1945, in Yokohama, *New York Times* reporter Robert Trumbull caught up with Lou and wrote furiously as Zamperini relayed his incredible tale. It appeared in the *Times* and was picked up by papers across the nation, including the *Torrance Herald*. It was the first time anyone in his hometown knew that Lou was alive. From Yokohama, Lou flew to Okinawa with this group of British and Australian prisoners. Lou is in the first row, third from the left. (Courtesy Louis Zamperini.)

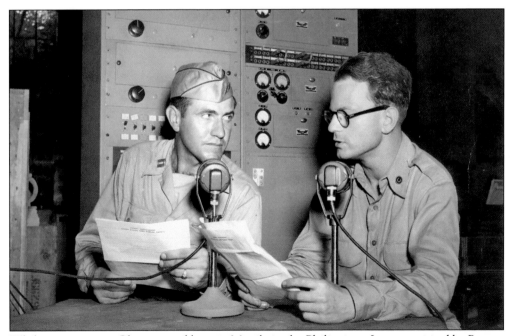

While recovering in Okinawa and later in Manila in the Philippines, Lou was visited by *Reuters* journalist Joe Laitin, who convinced the former POW that he should make a radio broadcast. By ravenous eating, much of Lou's weight had returned when he made this Sunday-morning broadcast from Manila in September 1945. (Courtesy Louis Zamperini.)

With his normal weight and strength regained, Lou flew to San Francisco where his brother Pete met him. They both returned to Long Beach on October 5, 1945, for a long-anticipated family reunion. Pictured here, from left to right, are brother Pete, sisters Virginia and Sylvia, dad Anthony, Lou, and mother Louise. Mom's intuition had been correct, and her prayers were answered. Lou came home to tumultuous Torrance and Hollywood welcomes that lasted for months. (Courtesy Louis Zamperini.)

Lou Zamperini met and married Miami debutante Cynthia Applewhite, but as reality returned, he sought refuge in the bottle, unable to shake the unrelenting nightmares of The Bird. One day, Cynthia dragged him to a tent service by visiting evangelist Billy Graham. Lou recalled those thousands of prayers he made on the raft and in the camps. With Dr. Graham's help, Lou stepped forward, ready to turn his life around. (Courtesy Louis Zamperini.)

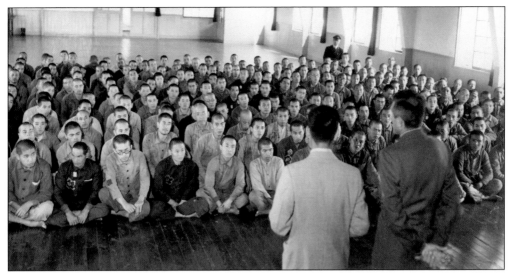

In time, Lou's conversion became genuine and complete. The nightmares stopped and as a former Olympian and war hero, he was in great demand as a speaker. In mid-1950s, he addressed his former guards at Tokyo's Sugamo Prison, telling of his conversion and forgiving them. Many wanted to meet with him in smaller groups. The Bird, however, remained in hiding for over seven years until the war crimes statute of limitations expired. (Courtesy Louis Zamperini.)

Lou continued as a speaker, enrapturing audiences with his almost unbelievable experiences. On April 7, 1954, Ralph Edwards picked up Lou's story on his *This is Your Life* television program. Pictured here, from left to right, are (first row) Mr. Edwards, Lou's father and mother Anthony and Louise Zamperini, Lou and his wife, Cynthia, and daughter Cissy; (second row) Lou's B-24 pilot Russ Phillips, USC track Coach Dean Cromwell, Lou's sister Sylvia, brother Pete, and Olympic sprinter Jesse Owens. (Courtesy Louis Zamperini.)

From the Hollywood Presbyterian Church, Lou began the Victory Boys Camp, a sports and athletic program for disadvantaged youths. Dave McCoy, owner of a Mammoth Mountain ski area resort, supported Lou with equipment and lift tickets. In 1957, Lou and Cynthia enjoyed Mammoth Mountain, as well as the ski areas surrounding Los Angeles. Cynthia passed away from cancer in February 2000, but Lou enthusiastically continues his Victory Boys Camp program to this day. (Courtesy Louis Zamperini.)

An inspiration to adults and children alike, Lou frequently addresses local Torrance children in the pilot's lounge of Zamperini Field's General Aviation Center. Through the doors is a rotunda exhibit of the World War II history of Zamperini Field with bronze plaques commemorating Lou and the airmen who flew off to war from the Lomita Flight Strip. (Courtesy City of Torrance.)

BIBLIOGRAPHY

Published historical texts on the Lomita Flight Strip, Zamperini Field, the Torrance Airport, or the Torrance Municipal Airport, as far as is known to the author, are nonexistent. It is sincerely hoped that this publication may become an inspiration, a small sampling of the wealth of historical aviation material out there awaiting posterity to discover. A few published works that were helpful in providing additional historical material are listed below.

Alexander, Jesse. *P-38 Lightning.* Osceola, WI: Motorbooks International, 1990.

Boyce, Col. L. Ward, USAF (Ret), ed. *American Fighter Aces Album.* Mesa, AZ: The American Fighter Aces Association, 1996.

Davis, Larry. *P-38 Lightning In Action.* Carrollton, TX: Squadron/Signal Publications, 1990.

Elliott, Charles Jr., and Dennis F. Shanahan. *Historic Torrance.* Redondo Beach, CA: Legends Press, 1984.

Ethell, Jeffrey L. *P-38 Lightning in World War II Color.* Osceola, WI: Motorbooks International, 1994.

——— and Robert T. Sand. *Fighter Command.* Osceola, WI: Motorbooks International, 1991.

Hatfield, D. D., *Los Angeles Aeronautics 1920–1929.* Inglewood, CA: Hatfield History of Aeronautics, Alumni Library, Northrop Institute of Technology, 1973.

Maurer, Maurer. *Combat Squadrons of the Air Force World War II.* Washington, D.C.: U.S. Government Printing Office, Albert F. Simpson Historical Research Center, and Office of Air Force History, Headquarters, USAF, 1982.

Olislagers, Robert P. *Fields of Flying.* Encinitas, CA: Heritage Media Corporation, 1996.

Schoneberger, William A., with Paul Sonnenburg. *California Wings.* Woodland Hills, CA: Windsor Publications, 1984.

Stafford, Gene B., and William N. Hess. *Aces of the Eighth.* Carrollton, TX: Squadron/Signal Publications, 1973.

Underwood, John. *Madcaps, Millionaires, and Mose.* Glendale, CA: Heritage Press, 1984.

Zamperini, Louis, with David Rensin. *Devil at My Heels.* New York: HarperCollins Publishers (first edition), 2003.

DISCOVER THOUSANDS OF LOCAL HISTORY BOOKS FEATURING MILLIONS OF VINTAGE IMAGES

Arcadia Publishing, the leading local history publisher in the United States, is committed to making history accessible and meaningful through publishing books that celebrate and preserve the heritage of America's people and places.

Find more books like this at
www.arcadiapublishing.com

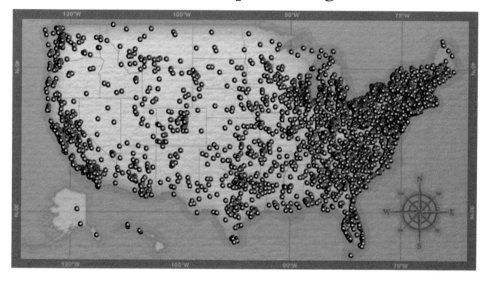

Search for your hometown history, your old stomping grounds, and even your favorite sports team.

Consistent with our mission to preserve history on a local level, this book was printed in South Carolina on American-made paper and manufactured entirely in the United States. Products carrying the accredited Forest Stewardship Council (FSC) label are printed on 100 percent FSC-certified paper.

MADE IN THE USA